Mastering Watercolour

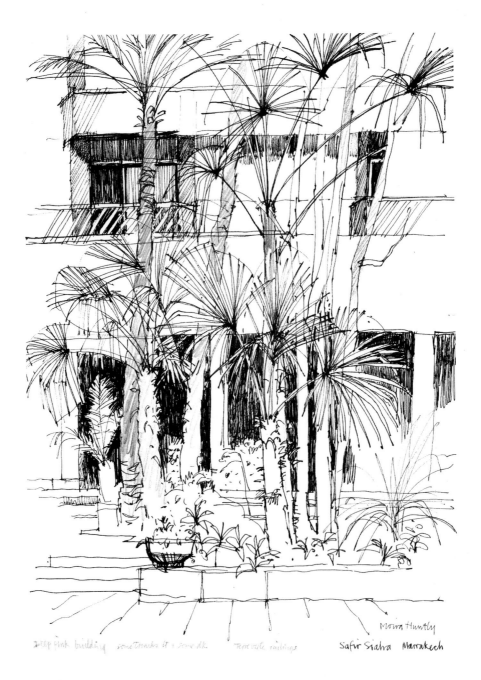

Moira Huntly

Deep pink building some trunks lt + some dk. Terracotta railings Safir Siaha Marrakech

Mastering Watercolour

Learn from five masters of the medium

NORMAN THELWELL
RAY EVANS
MOIRA HUNTLY
NEIL MEACHER
RAYMOND SPURRIER

B. T. Batsford Ltd • London

First published 1994

© Ray Evans, Moira Huntly, Neil Meacher, Raymond Spurrier and Norman Thelwell, 1994

Edinburgh Skyline (p. 37) is reproduced by permission of Royle Publications Ltd and *Bangkok* (p. 47) by permission of Harper Collins Ltd

Typeset by Goodfellow & Egan, Cambridge

and printed in Singapore

Published by
B.T. Batsford Ltd
4 Fitzhardinge Street
London W1H 0AH

British Library Cataloguing-in-Publication Data.
A catalogue record for this book is available from the British Library.

ISBN 0 7134 7430 0

The authors wish to dedicate this book
to the memory of the late
ROY PERRY, R.I.,
their friend and colleague,
who was to have been among the contributors.

Contents

Introduction

The only excuse for adding to the already plentiful supply of books about painting in watercolour is that this one is different. It is aimed at the many enthusiastic part-time painters who demand – and indeed deserve – something more sustaining than the numerous how-to-do-it books containing step-by-step recipes for producing look-alike pictures which have nothing much to say for themselves.

Many a book concentrates on materials and equipment, technical tricks and the mechanics of putting on paint, all of which are easy enough to learn. Scarcely any of them go *beyond* these matters to explore the real issues of painting: the thinking behind it, the attitude of mind, the creative impulse and the personal vision, to say nothing of the preliminary work which leads to a satisfying, professional result.

The aim of this book is therefore to carry on where others leave off. It provides five good reasons why painting to an easy-to-learn formula can never be right for serious painters. It contains contributions from five artists who, between them, have clocked up a formidable amount of experience in drawing and painting, and in tutoring and writing about art. They are also friends of long standing. As painting is a solitary occupation, they like to get together from time to time to spend a week sketching and painting; in the evenings they compare notes, swap sketchbooks and talk shop. Over the years, they have found this exchange of ideas stimulating and a valuable way of learning from each other, and from these experiences grew the idea of a book in which they could share their findings with a much wider public.

Each of them paints in watercolour, either on the spot or in the studio. Each has a characteristic style and technique, a personal view of the world and a unique way of working to express that vision. The following pages offer a privileged insight into their attitudes and working methods. They contain much practical advice and encouragement for those painters striving to improve their own work, and provide the incentive to explore some fresh approaches – even if only as an occasional exercise.

Those of you who are new to painting in watercolour should learn as much from what follows as more experienced painters. Indeed, if you are a beginner, it is important to adopt good habits from the outset and, early on, to start thinking like an artist and cultivating the urge to say something personal about your chosen subject.

Of the five contributors to this volume, four are members of the Royal Institute of Painters in Water Colours, although they also work in other media. The fifth, **Norman Thelwell**, needs no introduction. He has spent a lifetime in the frantic isolation of his studio, thinking up witty ideas for

cartoons with which to meet the all too imminent deadlines of newspapers and magazines with meticulously drawn comments on the more quirky aspects of British life. He is perhaps less well-known as a serious and contemplative watercolourist, working in a manner generally thought of as traditional to celebrate the quiet corners of the British countryside.

Ray Evans, painter and illustrator, who conceived the idea for this book, uses sensitive line and wash to portray architectural subjects with a clear perception of how buildings fit together. He is a restless and persistent traveller in search of subjects to fill his sketchbooks – those essential items of equipment without which, he says, he feels undressed.

Moira Huntly paints in a variety of media, one of her favourites being a combination of transparent watercolour and gouache. All of her work is based on strong draughtsmanship and a firm sense of design. In her finished paintings, she searches for the abstract qualities within a series of preliminary drawings, and aims for a satisfying balance between drawing and paint.

Neil Meacher is another painter and illustrator specializing in the British tradition of line and colour wash. His incisive draughtsmanship and witty line capture the essence of the places that he chooses to depict with a studied simplicity. Like those of Ray Evans, his sketchbooks are works of art in their own right.

Raymond Spurrier is primarily a draughtsman in the topographical tradition. In his paintings, he mixes realism with abstraction in search of the formal qualities of an ever-changing landscape which in recent decades has been transformed, as if in a race to keep up with the idioms of modern art.

If nothing else, this book demonstrates that there is more than one way of painting a landscape or townscape, even when the subject matter is similar and the common medium is watercolour. If there is one over-riding message in the following pages, it is that all of us engaged in painting, whether amateur or professional – and the dividing line is often tenuous – should be ourselves, doing our own thing in our own way.

Some of the pictures reproduced here may, inevitably, appeal more to you than others, depending on how well they accord with your own temperament, but all of them will contain lessons for the receptive. They are available here for analysis in the light of what the five artists have written about their methods and preoccupations. Having studied them, it is hoped that you will return to your own pictorial problems, and, by taking a leaf from the professionals' book, work at a personal approach to painting and gain from it as much pleasure (or pain!) as the authors have done.

Norman Thelwell

Almost all young children love to make pictures. It seems to be a natural instinct in human behaviour, and, perhaps because of their total lack of self-consciousness, the images that children produce are often surprisingly powerful. Sadly, the need to record imagined or remembered pictures tends to die out or be suppressed as people become older and involved in the serious business of earning a living.

When I was a child, most of the adults I knew considered that being an artist was not a proper job for a man. It was a bit like being a ballet dancer: it made adults strangely uneasy. Happily, since then, social conditions have become a little easier for many people, and there is a little more leisure time available for enjoying the visual arts and producing work of one's own. Indeed, the fact that so many amateur artists are keen to learn as much as possible about drawing and painting seems to show that the natural human instinct to make pictures does not die out altogether, but simply lies dormant, waiting for the opportunity to re-emerge.

It is both interesting and helpful to read all that one can of what other artists say about their own work. A vast amount of information is readily available in books written by artists who are successful in their own field. Most will give generous and useful information about which colours they prefer, and which pencils, pens, brushes and papers they find the best. You will notice, however, that no two artists ever recommend exactly the same tools of the trade or methods of using them. This is as it should be, for artists are individuals and there are no hard-and-fast rules about how to paint.

There is no shame in being influenced by the work of other artists. The fact is that we are all influenced by each other to some extent. If it were possible to be born and live in circumstances in which we never saw the work of any other artist at any time, not one of us would draw or paint the way we do. It is vitally important, at the same time, that we should all try to be ourselves in our own work, for it is the rich variety of artistic expression that is the chief delight of the visual arts.

As I have spent the greater part of my working life drawing and painting for widely distributed newspapers, magazines, books and publications of all kinds, I have received many letters from readers over the years. If one discounts autograph hunters and those who ask for 'any old drawings or paintings you have finished with', the bulk of the correspondence can be expressed in one short question, 'How do you do it?' It is a terrifying question, because the short, truthful answer is 'I don't really know'. What I do know, however, is that, if one starts drawing and painting things that fire one's interest and imagination and sticks to this principle, it will become easier with practice and an absorbing and fulfilling part of life.

A selection of pages from my sketchbook

SKETCHBOOKS

Sketchbooks are among the most important items in an artist's equipment. They come in a variety of shapes and sizes, but, on the whole, they tend to be easier to carry about than most other items. Landscape painters generally spend a considerable amount of time travelling about looking for interesting subjects, and some material inevitably appears at times and in places where it is inconvenient or even impossible to set up drawing-boards and easels.

On these occasions, the sketchbook is the perfect answer. You need only a pencil or pen to make notes and even quite detailed drawings, which will often be invaluable for later, more finished work. Although you will make many notes and sketches in difficult situations, constant practice within a limited time will increase your ability to observe more quickly and deeply, and will tend to produce a quality of sensitive line which you will, hopefully, retain in later work.

Subjects such as animals, people, boats and small landscape subjects may be jumbled together on the same page of your sketchbook, but will form a valuable set of references for future work.

Sketchbooks are like private diaries. They are personal notes intended for the artist alone, not for publication generally, and for this reason they often reflect the thoughts and personality of the artist more deeply than his or her more finished exhibition work.

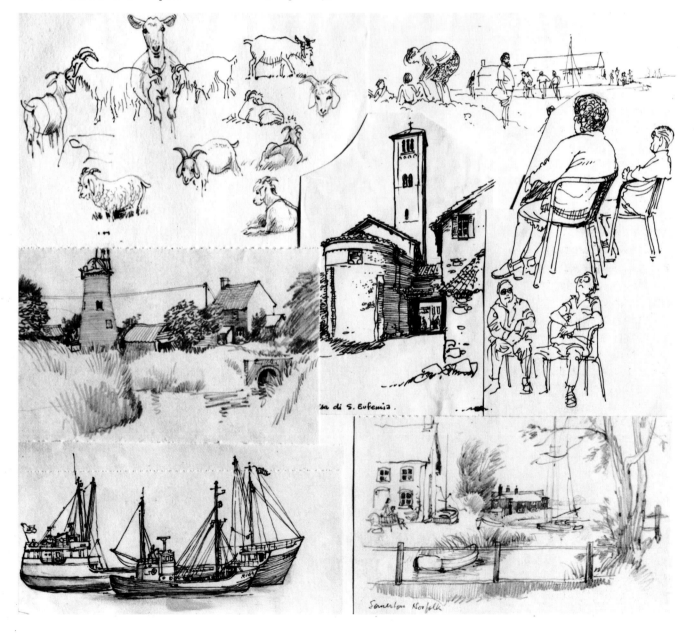

LANDSCAPE PAINTING

Landscape painters produce pictures in three different ways. They may go out fully equipped and attempt to produce a completed painting straight from nature, but more often they do as much as they can on site, and complete the work at home. This is a perfectly satisfactory way of working, provided that the original style and freedom are not lost by tightening up the technique or adding unnecessary detail in the second stage. When you start to be concerned about how far to take a painting, you have probably taken it too far already.

The third – and often the most comfortable – method is to work indoors from sketches. Most large watercolour paintings are produced in the home or studio, where the light source can be controlled and all tools and equipment are to hand. Work can then proceed in comfort, free from the vagaries of uncertain weather. It is pointless to claim that one method is better than another, for each can result in delightful paintings or disappointing failures. It is the final painting that matters, not the method used to achieve it.

In a perfect world, the first method would seem to be idyllic, but beginners should be aware of a few snags. Open-air painters tend to travel around looking for a subject, hung about with their equipment like animated Christmas trees and wishing they had left most of it at home. Finally, they settle for a subject rather less than inspiring because time is getting on.

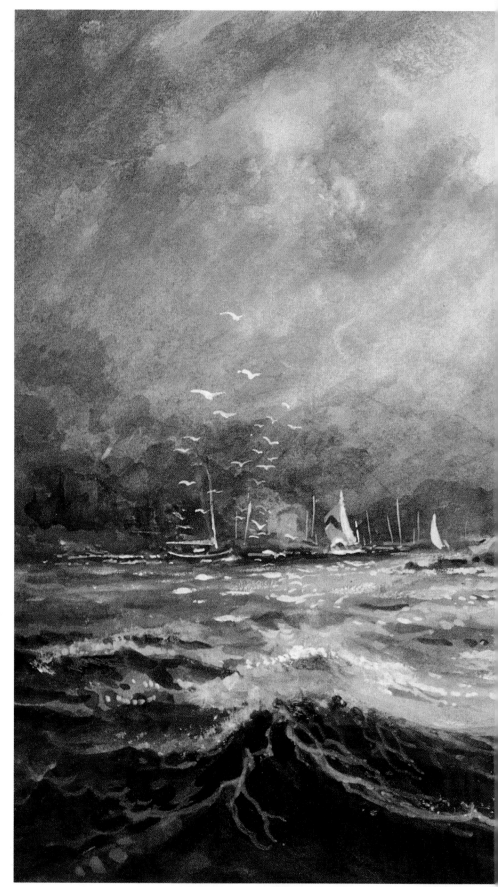

Rough Water at Dartmouth Castle

196 × 300 mm (7¾ × 12 in)

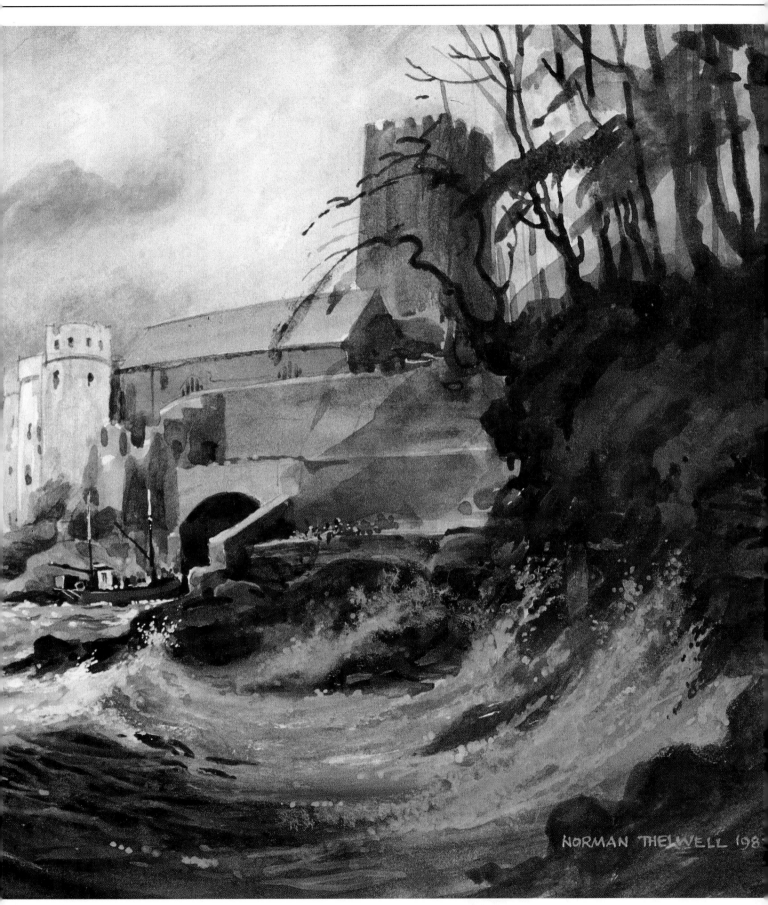

They set up their stool and easel, and lay out their equipment with the precision of competition anglers. They then notice that, when they face their subject, the sun is shining full on their white paper so that they will become 'snow-blind' in seconds, and realize that the only thing they have forgotten is their umbrella. In order to resolve this problem, they shift about until they can cast their own shadow on the paper, and then have to observe their subject by twisting their neck.

The weather is fine, perhaps a bit too hot (or cold), and there is a fitful little breeze which keeps flicking the corner of the paper up and down until the drawing-pin falls into the nettles. They stick the corner down with a bit of sellotape and press on. Apart from the damned horse-flies, all is now well, and painting proceeds at some speed because the sun has moved round and only half the paper is now in shade. The paper is more or less covered with lush washes of colour when a bumblebee drops heavily into it and creates havoc. They decide to carry on regardless, until they become aware that a herd of curious cattle is closing in behind them.

They hide their effort when they get home, with the excuse that they could not find an interesting subject. Some months later, they come across their creation again at the back of a drawer, set it up and look at it. More often than not, they will think: 'I wish I could paint with that creative vision, vigour and excitement when I'm working at home.' It is as well to remember when we are painting that we are not there to compete with the camera. We are there – or should be – to produce our own interpretation of the subject that has fired our interest and imagination.

PAINTING IN THE '90s

It is surprising how many interesting and very paintable subjects are first glimpsed these days through the windscreen or side windows of a speeding car. This is no great problem if you can stop the vehicle in a safe place without causing a traffic pile-up. The slightest error of judgement, however, may result in your looking at a rather less interesting view through the window of a police car.

This sort of thing tends to cut landscape artists off from a considerable part of our birthright. I sometimes find myself envying Turner, clumping happily along on horseback where every prospect pleased, where attractive foregrounds and groups of picturesque peasants were waiting round every corner. It is difficult to find good foregrounds when driving

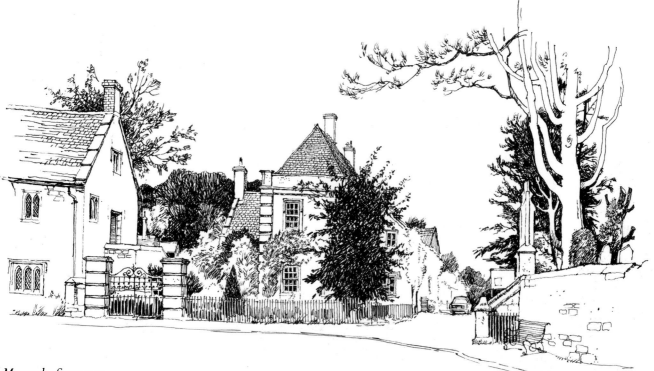

Martock, Somerset

170 × 290 mm (7 × 11½ in)

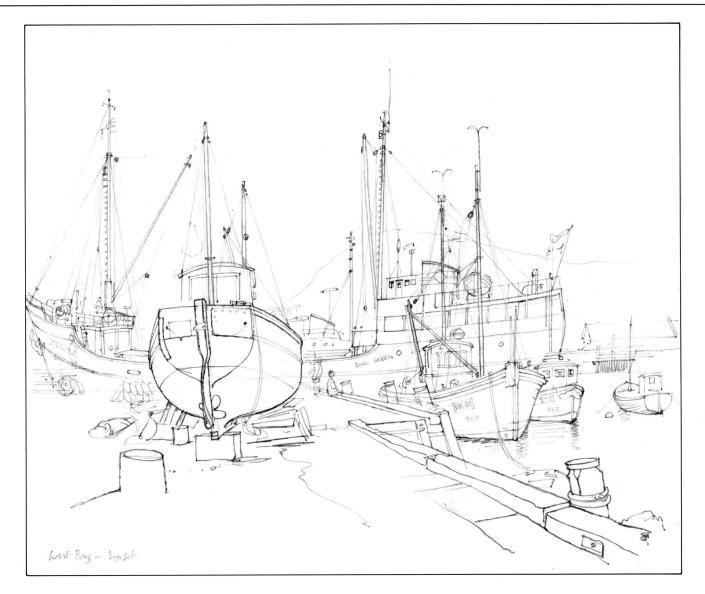

West Bay, Dorset

180 × 240 mm (7 × 9½ in)

along miles of four-lane motorways, or trying to get far enough into the side of country lanes to allow gigantic machines to squeeze by, and the only peasant you are likely to see will be tucked up inside his tractor cab listening to his radio.

But Turner had his own problems too, no doubt, when he painted the scene where his coach slid off the road into a snowdrift on his journey home from Italy, and who would envy him being lashed to the mast of a ship so that he could study at first hand the storm raging about him? I have often wondered what the crew of the ship (who were also battling to avoid a watery grave) said to Turner when he shouted: 'Would you lads mind lashing me to the mast so that I can get a better view?'

I have also read that Cotman, when painting his exquisite picture of Croyland Abbey, was so molested by local louts that he '. . . was obliged to give one of the ringleaders a sound flogging' before getting on with his painting. He must have been a tough fellow. I have looked long and carefully at his masterpiece, and can find no evidence that his hands were shaking. The painting remains benign, serene and lovely.

So perhaps, after all, we are no worse off than many of our heroes of the past, and should not grumble if we find that our car has been clamped while we were making a few sketches of attractively derelict high-rise flats.

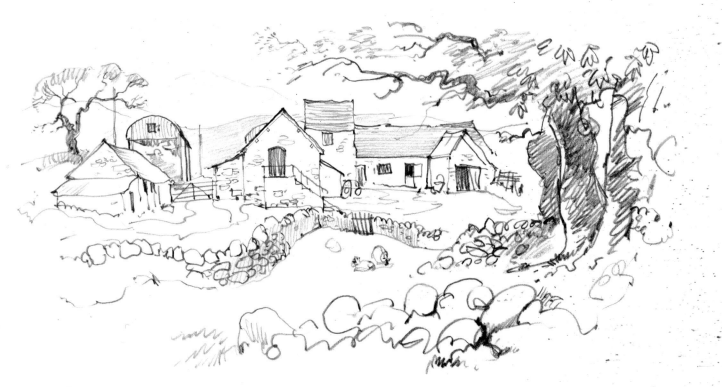

Sheep Farm near Corwen

120 × 225 mm (4¾ × 9 in)

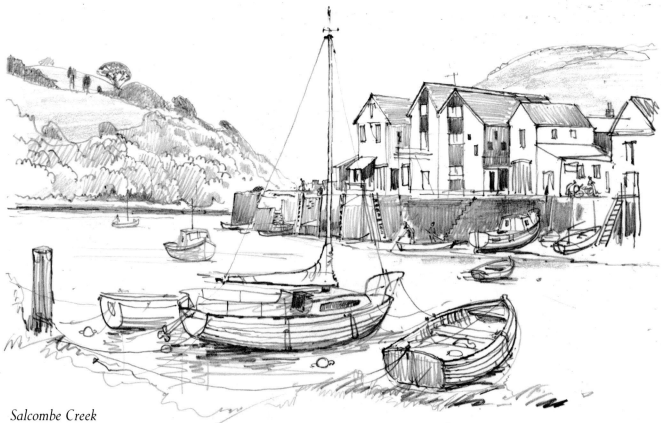

Salcombe Creek

130 × 210 mm (5 × 8 in)

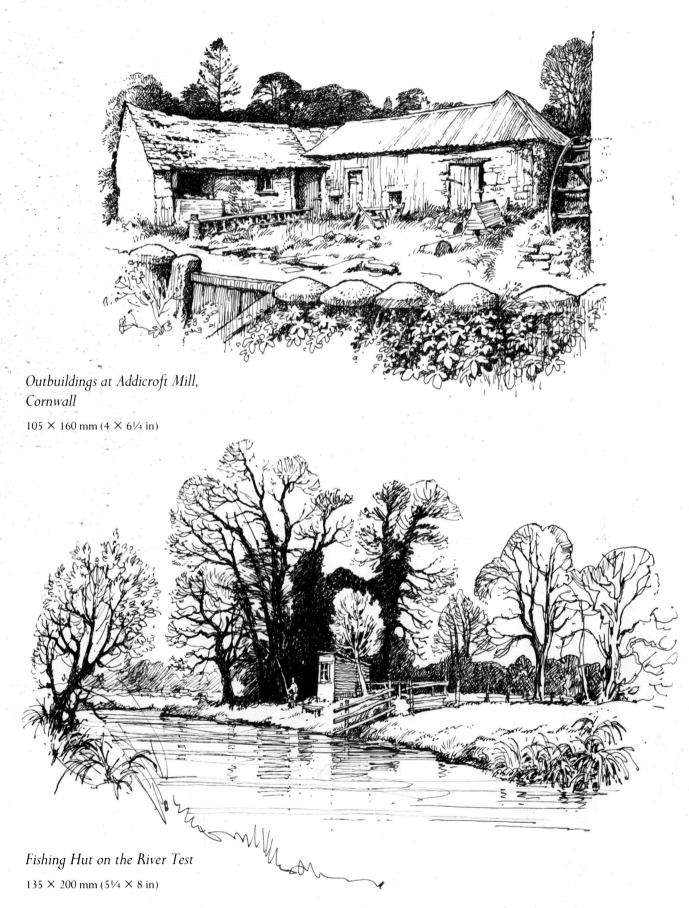

*Outbuildings at Addicroft Mill,
Cornwall*

105 × 160 mm (4 × 6¼ in)

Fishing Hut on the River Test

135 × 200 mm (5¼ × 8 in)

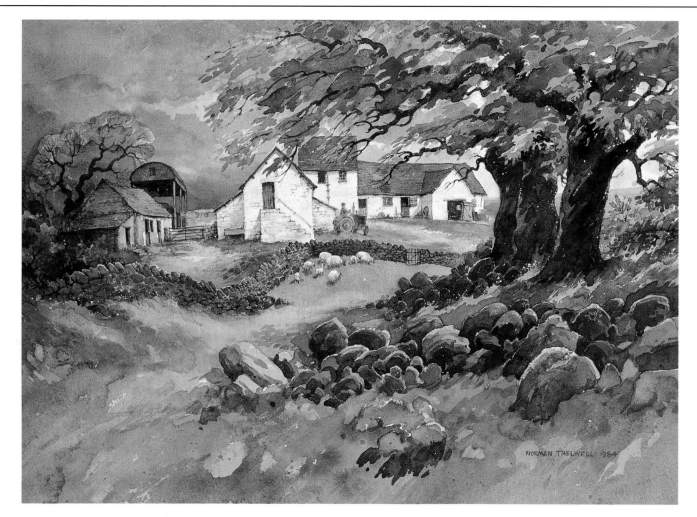

SHEEP FARM NEAR CORWEN

I spotted this scene when driving along a fairly busy stretch of road near Corwen in north Wales. I managed to pull off the road safely only a few hundred yards further along, apologized to the rest of the family and dashed back with sketchbook in hand and a pencil between my teeth.

I had to be fairly quick, because I had already done the same thing several times that day and we were all supposed to be on a carefree holiday. If you can remember to take a camera, it can sometimes be useful to remind you of certain details that you may have overlooked when doing this kind of lightning sketch. Generally speaking, however, I find that a drawing –

however slight – is likely to pick up certain rhythms which are less apparent in photographs.

Even a small sketch made on the spot will make you look more carefully, and for a somewhat longer time, than simply aiming and clicking a camera will do, so that the particular qualities of the subject are more permanently retained in your mind.

I carried out this painting later in my studio, based on the brief sketch (page 14 top) and the impression left in my mind while making it.

Sheep Farm near Corwen

375 × 525 mm (15 × 21 in)

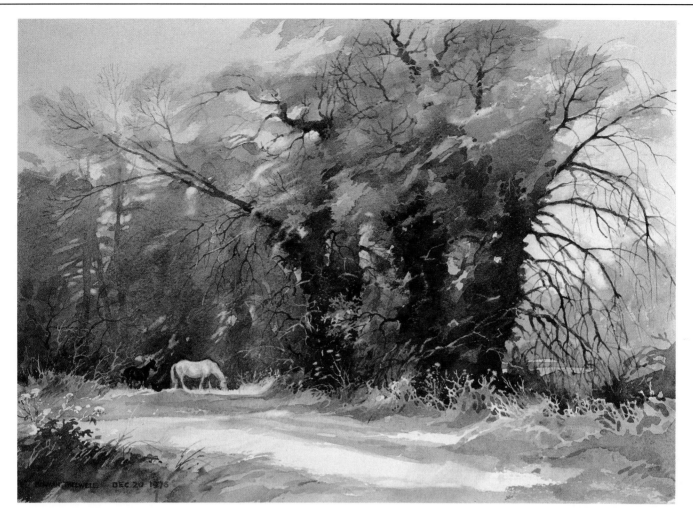

Frosty Morning, Hampshire

I saw this subject in my neighbour's garden one very beautiful morning in December. I knew the ancient alder trees very well, but that morning they had been transformed, like everything else, by brilliant crystals of ice which encased the vegetation like Christmas decorations.

I was impressed by the strong, fan-like spread of the trunks and branches, and intrigued by the contrast of the soft blue-grey of the general atmosphere and the warm, rich browns of the trees, from which many of the ice crystals had already been shed.

The pale sun was already out and I knew that the whole scene would change very quickly, so I made a pencil sketch with notes on colour and atmosphere, and then returned to my studio to paint. I placed the horses to provide a focal point, and achieved the effect of frost by painting in the small, dark shapes between the weeds and grasses, leaving the white paper to suggest the coating of frost particles.

Apart from a few touches on the lower left-hand corner, I did not use any body colour in this painting.

Frosty Morning, Hampshire

230 × 320 mm (9 × 12½ in)

Hawkes Farm, Braishfield

This farm is on the outskirts of the village in which I lived for nine years. I must have passed it many times when driving to and from Winchester and beyond, without feeling that the house was a particularly interesting subject to paint. One morning, however, when I was having a leisurely walkabout, I had time to look at it more carefully, and changed my mind. It was not so much the house that attracted me as the building seen within its setting.

The mass of red brick and tile seemed closely guarded by the dark conifers on either side. The pattern of the fencing gathered up the eye, and carried it swiftly on between the

main house and the smaller buildings to a half-glimpsed yard beyond, and then back across the front of the house to the washing fluttering on the clothes' line. The telegraph pole in the foreground carried the eye upward, and the wires looped it down again before it, too, disappeared into the yard beyond.

There were horses in the field on the right, but grazing animals cannot be expected to pose for pictures and I felt that something was needed to continue the movement from the fencing to the

Hawkes Farm, Braishfield

260 × 355 mm (10¼ × 14 in)

washing line. I therefore added the horses in that position, leaving one of them white to form the link.

The painting was almost complete when the owner came down the path and apologized for leaving the washing out on the line. He looked rather puzzled when I told him that I liked the washing just where it was.

I was able to complete this painting out of doors, because at that time I had a camper-van with a large sliding door, which was fitted out as a travelling studio. This enabled me to work in considerable comfort for as long as the work required.

The Bridge at Machynlleth

There are several locations in the area of the bridge which afford picturesque views of the structure and its surroundings, but I was keen on this occasion to look for some aspect which might be more interesting than the obvious angles.

After spending some time examining the subject, I decided to base my composition on the geometrical shapes and colours of the stone, metal and wooden objects at the end of the bridge. The angle of the sunlight was important in bringing forward the attractive patterns created by the strata of the stone gateposts and bridge abutments. The metal gate and rails made interesting patterns with the shapes of the simple wooden ladder and the telephone pole, with its angled wooden support. The telephone poles in the background echoed the vertical thrust of the foreground pole.

Keeping the bridge itself in deep shadow ensured that its elliptical arches did not fight with the foreground shapes. This also meant that the brightly lit top edges of the bridge walls carried the eye on to the row of white cottages beyond.

The Bridge at Machynlleth

355 × 500 mm (14 × 19½ in)

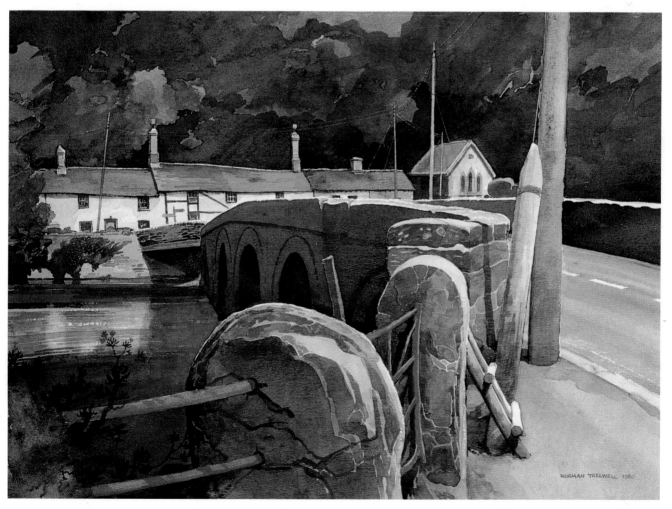

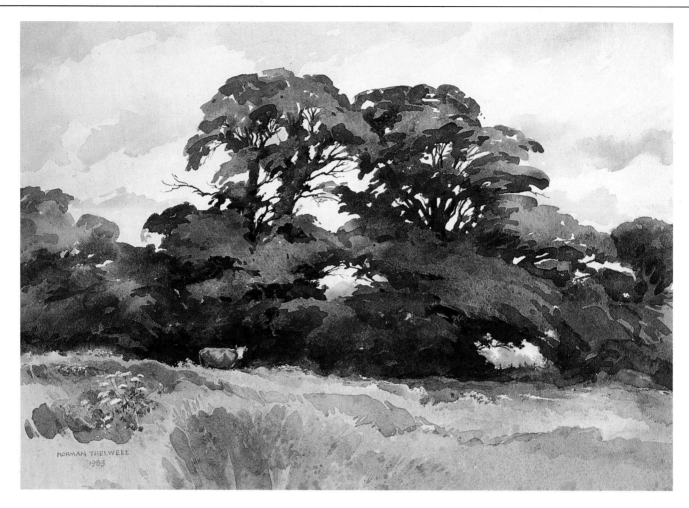

NORMAN THELWELL
1983

THE LONELY COW

There is so much material calling out to be painted that it is especially interesting when one becomes aware of some special mood or feeling about a particular place. I have always been fascinated by trees of all kinds and they are a joy to paint, but, when I came upon this scene in a Hampshire field, I knew instantly that it had a special quality of its own.

The dark trees had an ancient monolithic feeling about them. The grass was wild, deep and neglected, and there was a single cow with a white face watching me, as still as a statue, as if I were an unwelcome intruder in its private world.

It is unusual to come across a lone cow in a large field, and I think that if there had been other cattle present, the scene would have lost its special nuance. I had only a small sketchbook with me, and I was aware that the strange feeling of the place was unlikely to remain for long, so I made a simple sketch of the tree masses and went home.

I carried out the painting in the studio, mainly from the feeling that the scene had produced in my mind.

The Lonely Cow
375 × 525 mm (15 × 21 in)

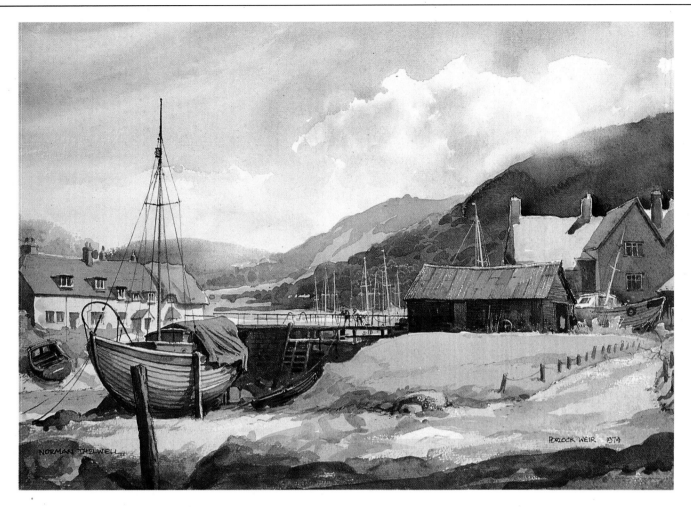

PORLOCK WEIR

I completed this painting out of doors one pleasant afternoon, when a group of us were painting on Exmoor. The composition was considerably wider when we arrived back at our hotel near Tarr Steps. While organizing an exhibition some days later, I foolishly laid my painting on the floor and a fellow-sketcher dropped a chair on it, so that one leg went straight through the paper. Well, I did ask for it, I suppose.

I consigned the painting to my disaster collection for about ten years before I happened upon it again. Apart from the open wound, I did not dislike it altogether, so I tried laying smaller mounts on to it to see what might happen. When the torn section was hidden, I felt that the composition was rather better than it had been when first painted, and a few strokes with a sharp knife changed it to its present proportions.

I mention this matter because I would advise that you always examine your work carefully before consigning it to the dustbin. Quite a lot of highly successful artists try this kind of rescue operation – often with great success.

Porlock Weir

255 × 355 mm (10 × 14 in)

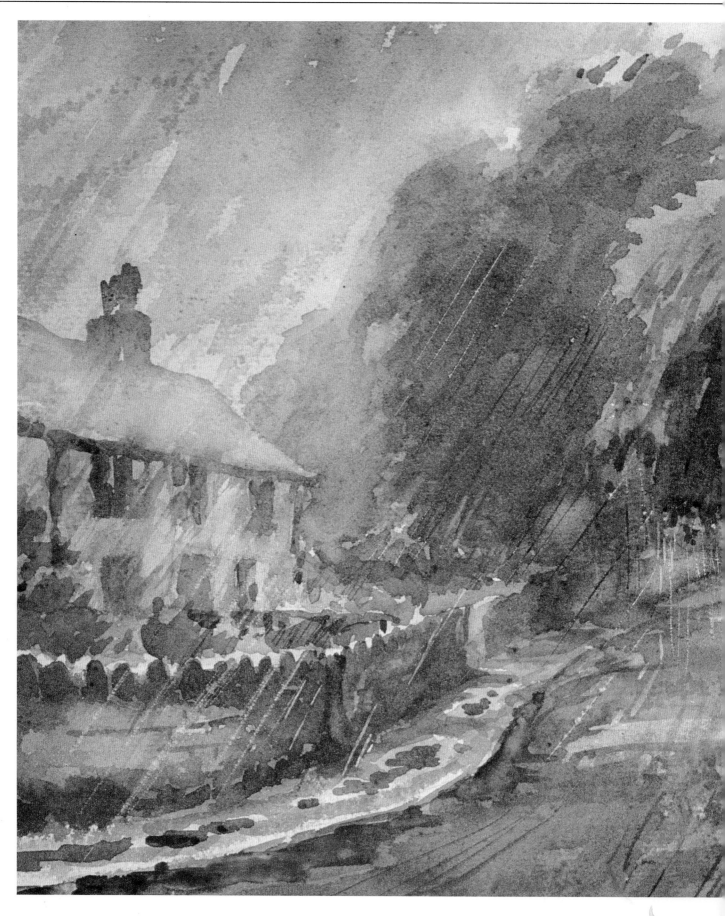

WET DAY AT WOODCHURCH, WIRRAL

One of the snags of painting out of doors in the British Isles (which I omitted to mention in my earlier list) is that, even if there are no other disasters, it will probably pour with rain. It is quite possible, however, to produce work while sitting inside a car, even if you have to keep the windscreen wipers going. I have had to do this on numerous occasions, and several times when it was snowing. It is usually worth it, as painting the weather can be fascinating if you can keep the bulk of the downpour off the paper one way or another.

I was due to meet a group of art students on the occasion I completed this painting, but no-one else turned up and I was not surprised. I am ashamed to admit that, if I had owned a car, I would have gone home too, but, being a penniless student myself at the time, I had only a bicycle and I didn't fancy riding five miles through torrential rain. The only shelter available was the lych-gate of the village church, and there was quite a lot of water dripping through the roof of that.

At the time I felt that my lonely effort was a disaster, but when I was warm and dry once more I was not so sure. Perhaps, after all, we must suffer for our art.

Wet Day at Woodchurch, Wirral

190 × 260 mm (7½ × 10¼ in)

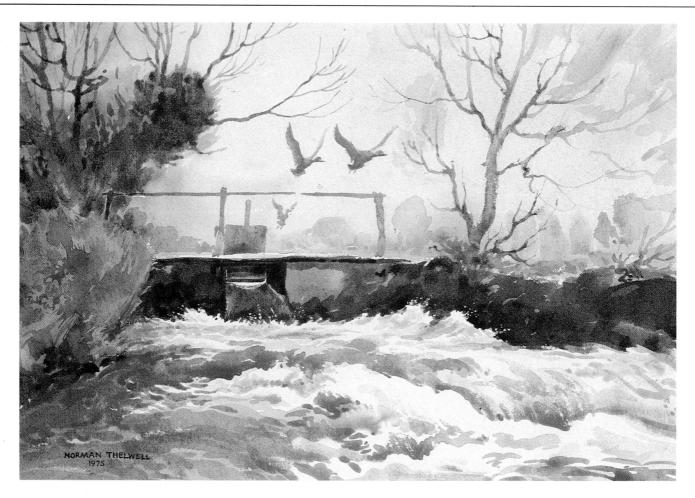

TUMBLING BAY
ON THE RIVER TEST

Water is a very difficult element to deal with in landscape work, and needs a great deal of careful study. Like clouds, water is continuously influenced by light and wind, but, being heavy, its behaviour is also dependent on the sea or riverbed over which it flows.

Every rock on a piece of coastline and every clump of weed in a river changes its speed and direction to some extent. Once the theory of reflections is understood, it is fairly easy to paint water in flat, calm conditions, but, when in motion, it takes a lot of careful observation to be convincingly interpreted in paint. I have carried out a number of drawings and paintings of this sluice-gate on the River Test, which is

ideal for trying to understand the movement and flow of water. Even small adjustments of the gate changes its behaviour immediately.

Incidentally, if I am introducing flying birds into a composition, I make a number of simple shapes on a separate piece of paper, cut them

Tumbling Bay on the River Test

185 × 280 mm (7¼ × 11 in)

out and try them in various places before deciding exactly where to paint them in the picture.

Suffolk Hamlet

It was the rich, curving pattern of the foreground field that first attracted me to this scene. It offered an example of how human activity in the landscape can add to the natural beauty of the countryside. I needed to make only a very little adjustment to the pattern of furrows, groups of trees and middle-distance buildings to bring it all together in a satisfactory composition.

I think it is true to say that I have never once produced a picture in colour or black and white that has satisfied me completely in every particular, but there is no doubt that some pieces of work seem to go reasonably well from the start. I have found that, on the rare occasions when this happens, there is little one can say about the finished work.

A picture must speak for itself, and no amount of high-flown analysis, explanation or waffle will make it one jot better or worse than it is.

Suffolk Hamlet

280 × 500 mm (11 × 19½ in)

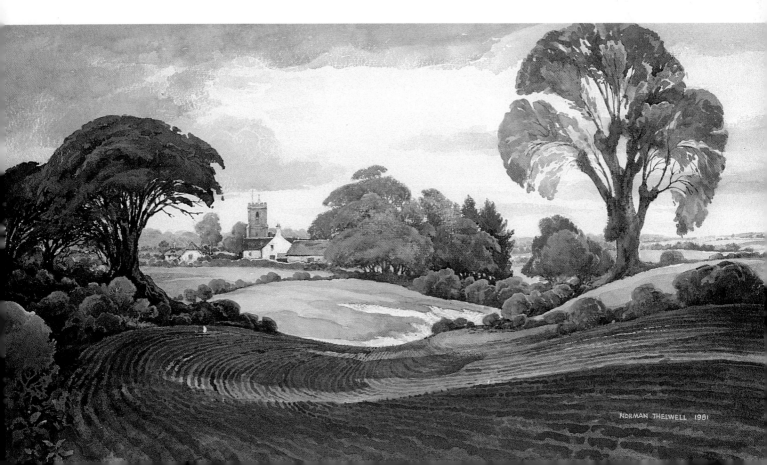

FISHING BOATS
GOING TO SEA

This is an imaginary scene carried out in the studio from sketches of fishing boats drawn in my sketchbooks. I have mentioned elsewhere how baffling water can be when in motion. Out at sea its behaviour can be quite beyond analysis and one can only hope to give some feeling of its restless power.

Here I tried to suggest its movement by the varied angles of the fishing boats as they rose and dipped in the waves, and by referring to notes I had gathered of wave forms in the open sea. The piece of driftwood in the foreground was helpful in suggesting distance between it and the boats, and the seagulls flying low in the troughs of the sea helped to give a feeling of scale to the wave forms.

I was making notes of sea movements through the window of a cross-channel ferry one day, when a couple of young passengers looked over my shoulder in complete silence. As they moved away I heard one say to the other: 'He's a nut-case! There's nothing out there.'

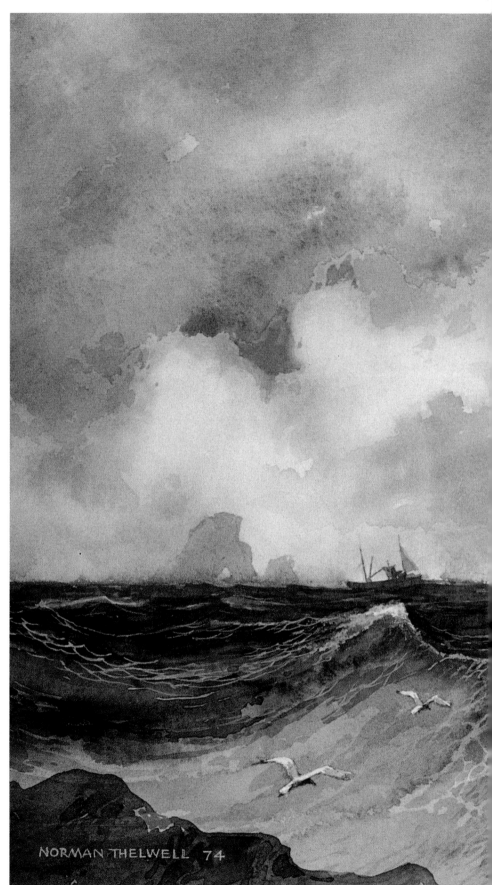

Fishing Boats Going to Sea

255 × 400 mm (10 × 15¾ in)

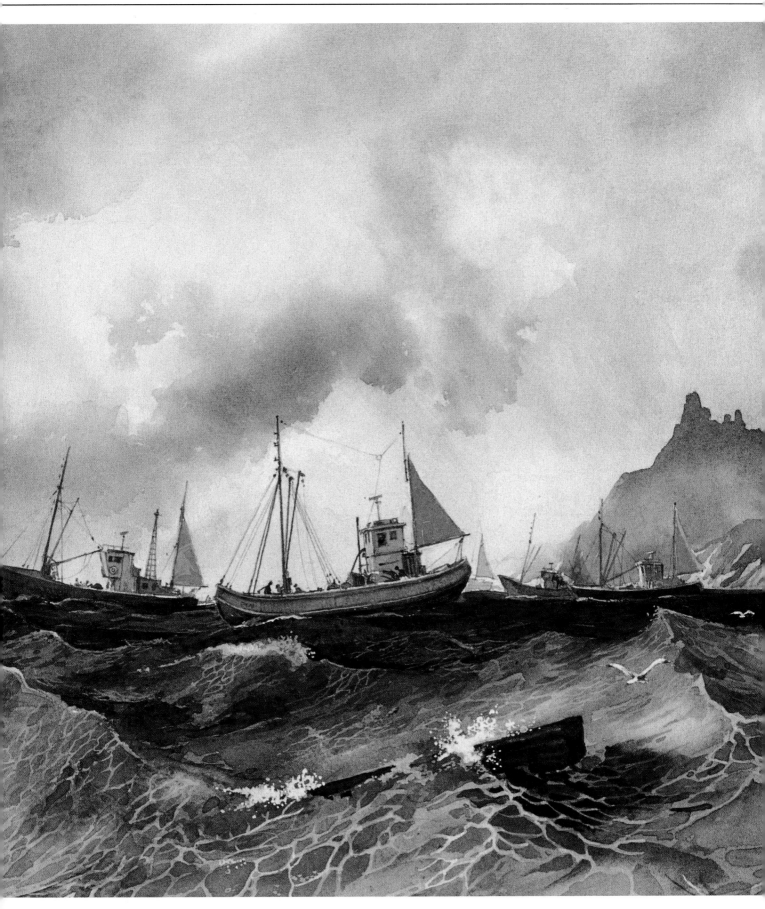

Deserted Cottage on Bodmin Moor

230 × 340 mm (9 × 13½ in)

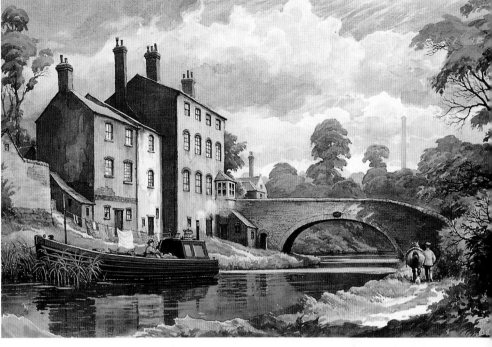

Roving Bridge at Aldersley Junction

370 × 540 mm (14¾ × 21½ in)

ROVING BRIDGE AT ALDERSLEY JUNCTION

When I was a student at Liverpool College of Art, shortly after the 1939–45 war, I spent a lot of time drawing and painting on the canal system at Ellesmere Port. Later, at Wolverhampton, I took art students out to work on the local canals. That was in the fifties when the navigations were much neglected and falling into disrepair, but they were still rich in industrial architecture.

The view here was painted much later from the many notes and sketches I made at that time. This was before public interest returned and much rescue work was started to preserve these often very lovely stretches of inland waterways. This rescue work is still being carried out today.

DESERTED COTTAGE ON BODMIN MOOR

I think of this painting as containing 'mood', rather than any other particular quality. Although very different in subject matter, it has something of the same feeling as the painting of the cow on page 20.

Those who know Bodmin Moor in Cornwall will usually agree that it has a strange, rather eerie atmosphere which is difficult to define. Perhaps it has something to do with the ancient standing stones, strange rock formations and abandoned engine houses which are scattered about its surface. Even the long coarse grasses seem to moan and complain as they rock and bend in the constant wind, and many of the granite-built houses and cottages seem to have been long abandoned. One cannot help but wonder about their history and the people who must have occupied them.

I once bought a crumbling old watermill on the edge of the moor and spent some years rescuing it from a lingering death, so I got to know the area rather well. This cottage seemed to hold something of the mysterious, slightly forbidding atmosphere of the moor. I made only a simple sketch of it while I was there, and painted the subject at home after, trying to recapture the remote and lonely feeling.

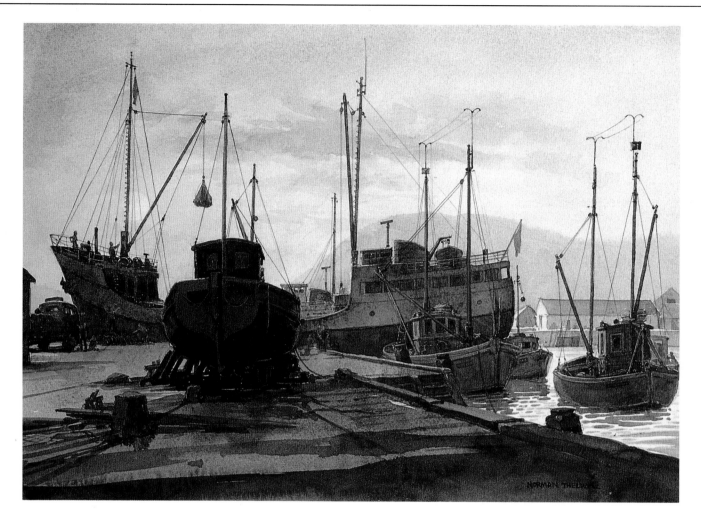

UNLOADING CARGO AT WEST BAY, DORSET

Most artists love to draw and paint boats of all kinds. From small dinghies to ocean-going ships, they seem to have a special beauty of their own. This may have something to do with the fact that they must be well-designed to perform with maximum efficiency. Boats also have rigging, ropes, wires, masts, sails and spars. These create exciting patterns and textures so that they retain their fascination from the builder's slipway to the breaker's yard. Not surprisingly, they always look good when afloat, but they still look attractive when pulled up onto beaches, or abandoned on some rocky shore.

Although the beginner may often be approached by interested members of the public when working out of doors, it is very rare to meet hostility, provided that normal standards of behaviour are observed. There are exceptions to every rule, however, and one such encounter occurred when I was deeply engrossed in the drawing for this picture (see page 13).

One of the stevedores detached himself from his workmates and came striding across towards me with arms stiff and fists tightly clenched. 'What the b . . . h . . . do you think you're doing?' he bellowed. Luckily, he walked behind me and looked at my paper before taking a swing at me. 'Oh! Sorry mate,' he said. 'I thought you were one of those b . . . time and motion creeps. You an artist then?' I admitted I was. 'He's only an artist,' he shouted as he returned to his mates.

It took me several minutes to steady my hands before I could carry on being an artist again. How *did* Cotman manage to cope with paint and pugilism at the same time?

Unloading Cargo at West Bay, Dorset

235 × 345 mm (9¼ × 13½ in)

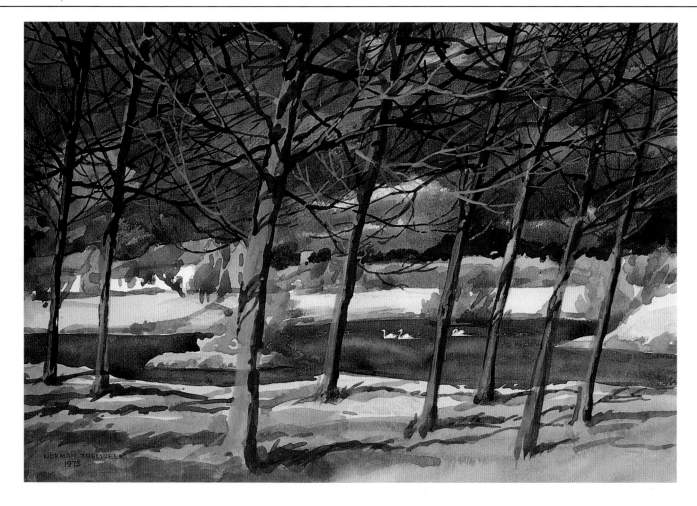

THREE SWANS ON THE LAKE

This rapid colour sketch was painted only about thirty yards from the spot which was the point of view of the autumn painting on page 31. The atmosphere was just as transient, but very much more dramatic and animated.

I had my painting gear with me at the time and decided to try a quick impression of the threatening scene. There was no time to stand and stare. I knew that I could only have a go and hope for the best, but I had been in that situation often enough before, and once in a while it had paid off. I was lucky really because the deluge of rain, which I expected at any moment, held off until I ran for cover in my studio – this can just be glimpsed on the extreme left of the painting.

Once indoors and, unbelievably, still dry, I used body colour to suggest sunlight on the trunks of the foreground trees, and to paint in the three white swans. The rapid brushwork in this particular sketch proved to be in keeping with the turbulent scene, adding rather than subtracting from the final result.

Well, we are entitled to a bit of luck from time to time.

Three Swans on the Lake

185 × 280 mm (7¼ × 11 in)

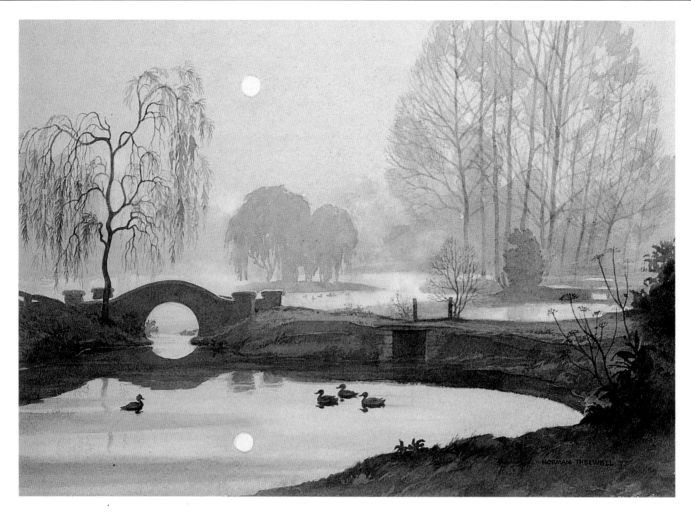

AUTUMN MORNING AT HERONS MEAD

Autumn Morning at Herons Mead

260 × 395 mm (10¼ × 14½ in)

I suppose there are few people who have not, at some time, been enchanted by the light and colours of an autumn morning, when the pale rising sun turns the mist to a golden glow and gives the landscape an almost dream-like quality.

Watercolour is a particularly suitable medium for trying to capture subtle atmospheric effects, but it was not possible, with a subject such as this, to settle down to paint it in a leisurely manner on the spot. For one thing, the effect was certain to be transient and to change rather quickly, and a rapid colour sketch was likely to destroy the quiet serenity of the scene. This peacefulness was essential to the

particular mood, so I made a simple pencil sketch of the main shapes and completed the painting indoors the same morning.

The important thing was to get the colour right. I used the fact that misty air obscures tedious detail and suggested distance by dividing the picture into receding areas of progressively paler tones. The ducks were placed to suggest quiet

relaxation and to contrast in tone with the distant bank of the pool, thus increasing the feeling of depth and distance.

31

Watch the Birdie

I make no apology for including this
tailpiece in a book about landscape
painting. After all, birds, animals
and human beings are part of the
landscape, and artists have been well
aware of this over the centuries.

I had been painting landscapes,
architecture, animals and a host of
other subjects from childhood before
I became intrigued by the endearing
lunacy of human behaviour, and
have continued to do so ever since.

Among the many hundreds of
human eccentricities I have dealt
with in the pages of *Punch* and many
other publications, my subjects
have, wherever possible, been set in
the landscapes of Britain, which I
love dearly.

Watch the Birdie

210 × 310 mm (8¼ × 12¼ in)

Ray Evans

I have been painting, sketching and illustrating for the forty-odd years since leaving art college in the 1950s. My happiest times have been with a sketchbook, and I have filled more of them than I can remember. A sketchbook should never be used for slavishly copying what we see in front of us, but as a book for thought as well as for drawing. I come back to my sketchbooks again and again for reference, and always find something new and interesting in them.

In this section, I have shown a mixture of my sketchbook and studio work in order to demonstrate something of my method of working as an artist. The work on these pages will, I hope, reveal my whole approach to painting in watercolour and mixed media, although I would point out that I am still liable to change my outlook, and so my work is constantly changing and developing. Having said that, the intention of this book is to show how five of us approach painting and drawing, and inevitably we each have our own style, recognizable as the work of that particular artist.

WHAT IS IT ALL ABOUT?

Unlike a painting style, which can alter quite radically, an artist's sketching style is unlikely to change rapidly, although it may only develop fully after years of experience. With painting, however, I could never be satisfied with one particular technique and with forever 'copying' this in my work. I would find that very dull, and in fact one of the reasons that I enjoy my painting and illustration work so much is because of the variety involved. I think it vital that artists should be continually experimenting with their painting and exploring new ideas, in order to bring a freshness and liveliness to the work, and to stretch themselves in terms of technique. It is very important to *enjoy* painting, and this enjoyment and satisfaction will come from stretching yourself and testing your ability in new spheres, rather than by finding one successful painting 'formula' and sticking to it.

During my working lifetime I know that I have learned from other artists, both past and present, as well as from my friends and colleagues. I am always very keen to look at my friends' sketchbooks, and to go out with them to watch them at work. This is one reason why I think that the idea of this book is a good one, and of use to other artists and those who are interested in painting.

I painted this picture to please myself rather than for a particular

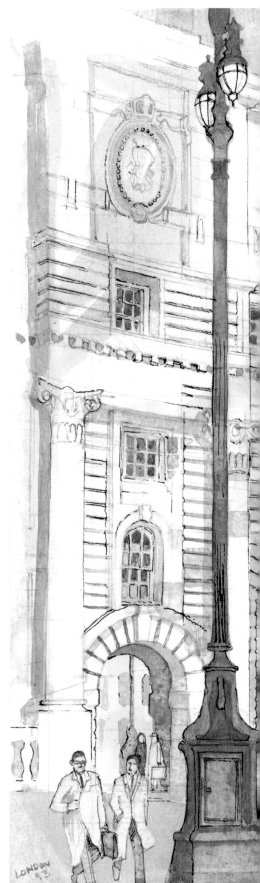

Admiralty Arch, London

266 × 305 mm (10½ × 12 in)

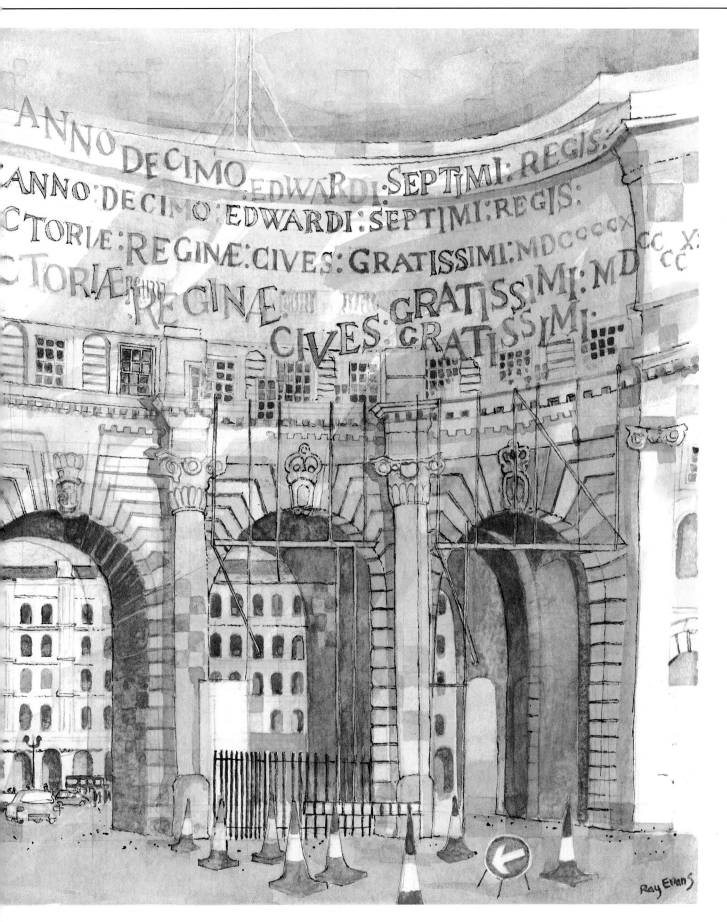

The Concert, Salisbury Close

103 × 153 mm (4 × 6 in)

Characters in a Taverna, Crete

120 × 90 mm (5¾ × 3½ in)

market. You may wonder why I have painted the classic Roman lettering in such a bizarre way. The reason for this was that, as I walked out of the Mall Galleries in London one fine and sunny afternoon, the Admiralty Arch gleamed white and rather stark, and the lettering seemed to dance before my eyes in the dazzling sunlight. I pulled out my small sketchbook and made some notes, sketches and compositional drawings, and then took a number of photographs of the subject. I always look for the unusual in my painting, and that is why I painted in this way.

In some of my studio paintings, as with this one, I draw a grid lightly in pencil to help to control the freehand pattern of vertical and horizontal shapes. Often I will take this squared pattern through into the painting – not aggressively, and sometimes even unconsciously – because I am enjoying the painting and the shapes and patterns that I am making.

A small sketchbook is my constant companion, and shown here are two pages from a 102 × 152 mm (4 × 6 in) book. I make sketches of this kind both as a pleasure in themselves, and to use as reference in the studio later. Often I will make my sketches in colour, as I find that recording colour in this way is an essential aid to re-creating atmosphere in a finished painting. I may include a considerable amount of detail in such sketches, as well as supplementing them with photographs and written notes.

I find painting in the studio from information collected on the spot the ideal way of working. A sketch can be completed quickly (often a necessity with the British weather), and the final painting worked on at a more leisurely pace. I also find that not having the subject in front of me enables me to 'stand back' a little from it, to be slightly selective and to decide on changes that sometimes make all the difference to a composition, and which I find more difficult to do with the reality of the subject in front of me. Some artists, for instance, might have omitted the traffic sign and bollards in the foreground of the painting shown here, but to me they emphasized the contrast of the classical architecture and the trappings of modern city life, and so I deliberately included them.

EDINBURGH SKYLINE

These paintings of Edinburgh derived from one fifty-minute sketch that I made one evening in the city as I sat with my wife on a park bench. I had been working on a commission to make some watercolours of the Balmoral area, and we were in Edinburgh for a night before starting off down to the south. I was overwhelmed by Edinburgh as a city, and, as we sat in the evening light, I pulled out a sketchbook and completed a sketch which I subsequently turned into the painting shown here in my studio. I sold the original sketch in an exhibition to a man from Edinburgh. I liked the tree placed where it actually was when I sat to make my sketch, and decided to include it in the finished painting.

Subsequently I was asked by a client whether I had anything of Edinburgh suitable for a forthcoming Scottish calendar. I sent them the picture (with the tree), and they liked it but preferred the composition without the tree, so I made a fresh watercolour of the subject, as shown overleaf. It was quite a challenge to re-compose the subject in this way, and I also had to adapt and 'slim' the buildings a little. I lightened the whole subject by using greater contrast in the tone values, both on the buildings and on the grass area of the foreground.

I am fortunate in that my illustration work has, for the most part, been complementary to my watercolour painting style and

Edinburgh Skyline

185 × 250 mm (7¼ × 10 in)

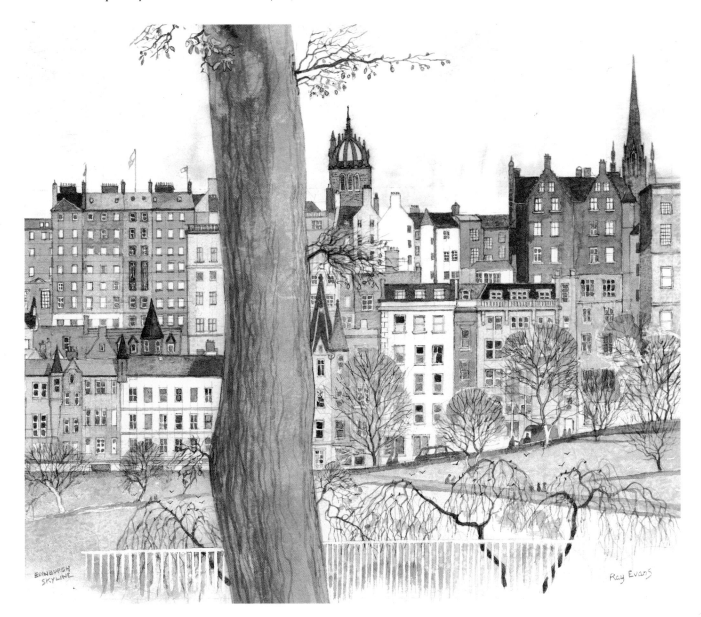

technique. I feel that illustration work of this kind has a discipline that is beneficial to a painter, provided that it does not stop his or her progression. My development as a watercolourist has taken place over many years, yet I know that I must progress with my work still further.

THE SHIRT, AIX-EN-PROVENCE

I had been in Aix-en-Provence for several days looking for a subject for a commissioned painting, and when I found the Place de Cardeurs I knew that I had found it. It was a large, open square sloping from tree-sheltered cafés at the top end down to the tall and picturesque old tenement houses, so typical of France, which lined the remaining three sides. The ground was paved with patterned stones and cobbles, and was entirely car-free (the cars were tucked away in an underground car park at the lower end of the square). There were people wandering about shopping, calling out to children and probably gossiping about their neighbours.

I sat on a bench in the morning sunshine, and made the pen-and-ink drawing shown on page 41. Although this was only a black-and-white sketch, it was detailed enough to provide me with sufficient information to paint the scene at home in my studio, and I had a good impression of the colours in my memory. For the painting (not shown here), I used an artist's watercolour pad measuring 305 × 405 mm (12 × 16 in), and my favourite light sketchbox. The painting took me about an hour and

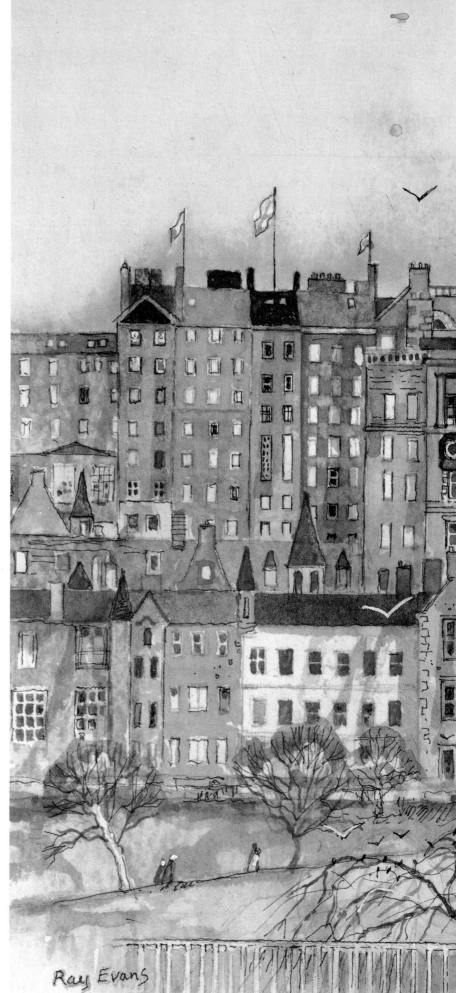

Edinburgh Skyline

266 × 305 mm (10½ × 12 in)

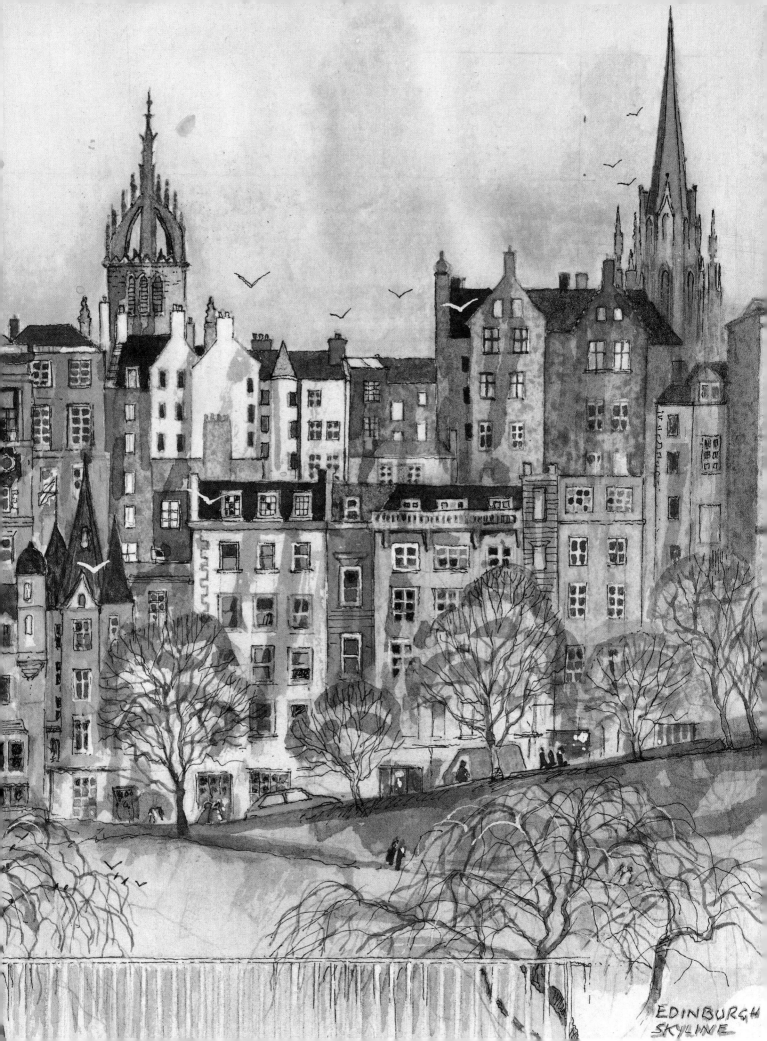

EDINBURGH
SKYLINE

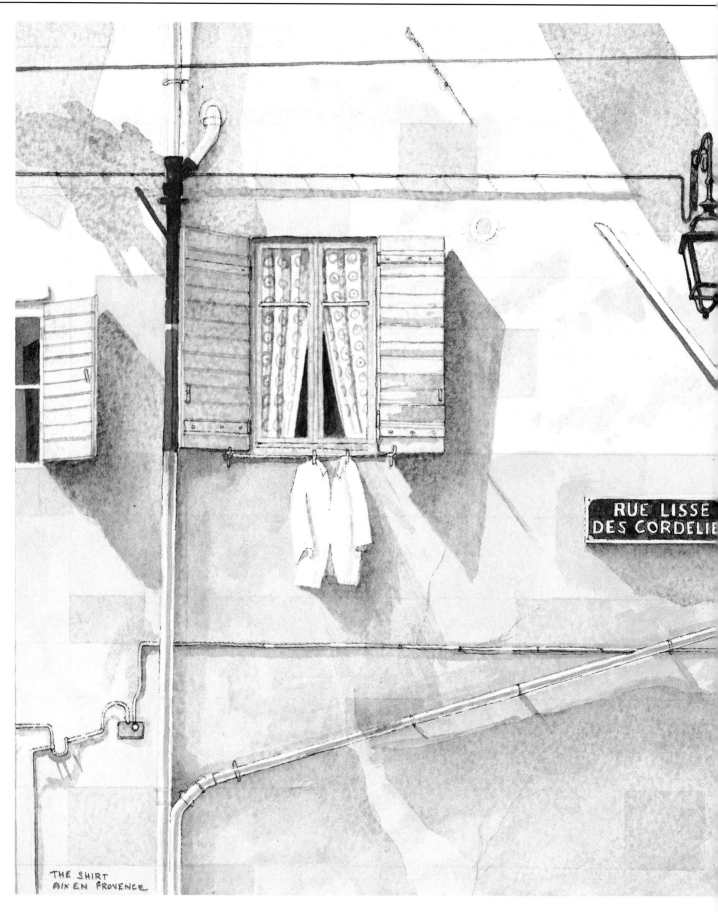

THE SHIRT
AIX EN PROVENCE

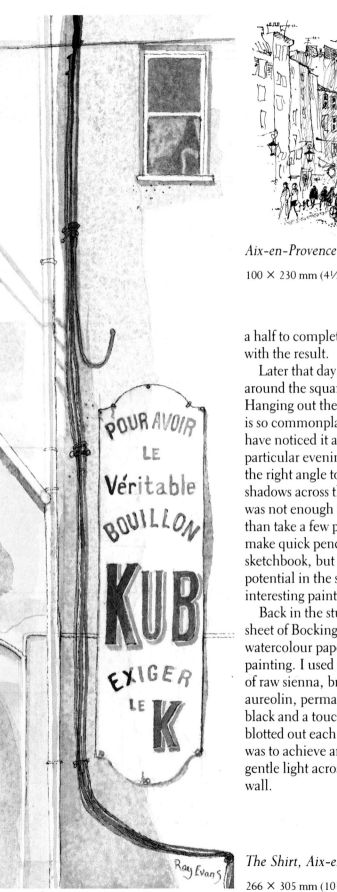

Aix-en-Provence

100 × 230 mm (4½ × 9 in)

a half to complete, and I was pleased with the result.

Later that day, while wandering around the square, I saw the shirt. Hanging out the washing in France is so commonplace that I might not have noticed it at all, but on that particular evening the sun was at just the right angle to throw long shadows across the pale wall. There was not enough time to do more than take a few photographs and make quick pencil notes in my sketchbook, but I could see good potential in the subject for an interesting painting.

Back in the studio, I stretched a sheet of Bockingford 300 gsm watercolour paper ready to start the painting. I used a very muted palette of raw sienna, brown madder, aureolin, permanent rose, ivory, black and a touch of cobalt blue. I blotted out each wash, as my aim was to achieve an effect of pearl-like, gentle light across the plaster-faced wall.

For detailed work, such as the lettering on the signs and the pattern on the curtains at the window in this painting, I always use the best sable watercolour brushes in the smaller sizes. For larger work, however, I often use square-ended and wash brushes made of nylon, or a sable and nylon mix, of which there are some excellent types on the market.

As with the painting on page 35, I painted this picture entirely to please myself, without thought of a possible buyer. This is one reason why I like to earn the bulk of my living by illustrating (and many illustrators were and are also good painters), as it gives me the opportunity to paint for my own pleasure as well.

The Shirt, Aix-en-Provence

266 × 305 mm (10½ × 12 in)

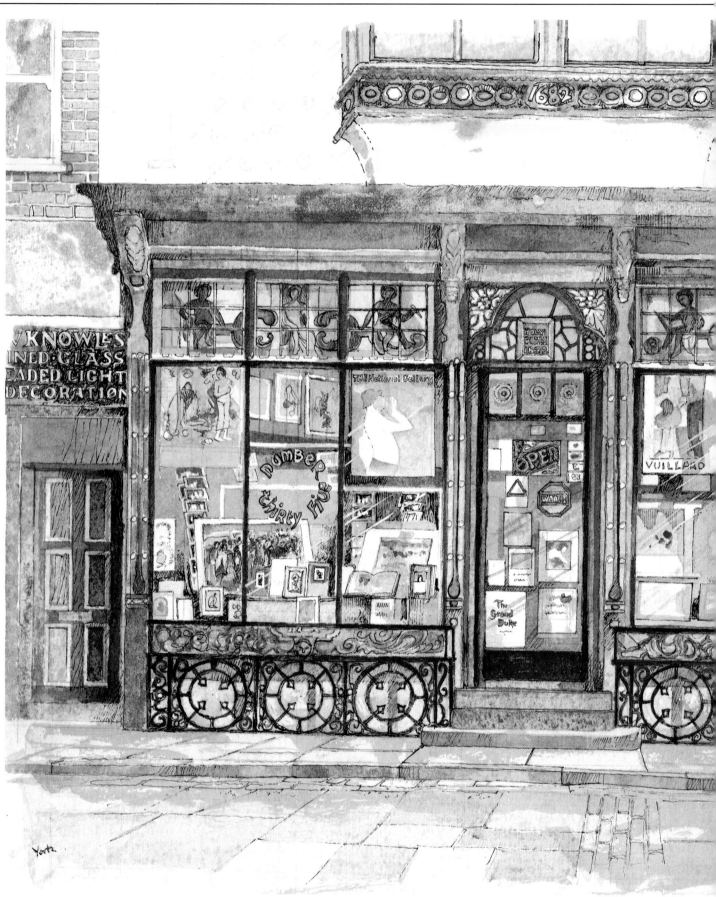

A Shop Front

For a number of years, I have been producing paintings for a series of calendars. This has given me a wonderful opportunity to travel around Britain sketching many fine historic houses, castles and manor houses, and later making studio paintings from my sketches, notes and photographic details.

One year this commission varied slightly, and I was asked to paint specified interesting shop fronts throughout Britain. This was a fascinating subject, and one that I greatly enjoyed. I was able to carry out many of the paintings on the spot without too much difficulty, usually in one sitting, although sometimes on rather crowded pavements.

Traffic was a nuisance, but I coped with this by working early in the mornings or in the evenings when it was at a minimum. The middle of the day can in fact be unpleasant for painting if the weather is hot, or you might have to sit in a position where the sun is in your eyes, making it difficult to paint *contre jour*. Shadows are more interesting in the morning or evening, but are also changeable, so I work quickly at these times of day, taking one-and-a-half to two hours at the most for this type of subject. I also use a camera to take details and close-ups, ready to use as reference for the finished painting, which generally takes two or three days to paint in the studio.

I was fascinated by the shop fronts that I painted, and discovered that Britain is rich in such subjects, even though many have been horribly modernized. I found this shop front in York. It was very rich in detail, and I made a careful pen drawing of it, but did not add any colour. I then took about fifteen photographs from all angles, including close-ups of details such as the ironwork. I also took close-up photographs of the contents of the windows from different angles, so that I could work out all the detail in the finished painting, and I found these particularly useful.

While making my drawing, I had to get up and down to look at several details more closely, such as the iron scroll-work, the details over the doorway and the lettering on the glass, which was difficult to see with the paintings and prints behind it.

This painting took many days to complete in the studio, but I found it immensely enjoyable to do. I made the windows, as the focal point, full of interest and colour, but kept the rest of the picture very muted, washing the colour out often to make subtle colours and textures. I painted the details carefully, using my photographs for reference, and used brown and grey ink to pick out much of the ironwork, the lettering and some of the items in the window.

A Shop Front

266 × 305 mm (10½ × 12 in)

STOKESAY CASTLE

As part of the commission mentioned on the previous day for a series of calendars, I recently visited a number of historic houses and castles, carrying out sketches, drawings and a watercolour of each, as well as making notes and collecting information about each building. The houses in question were all open to the public, so I had no difficulty in gaining access to them.

On one very wet August morning, we (my wife shares the driving and collects the research) set off for South Wales, hoping that the weather would clear by the time we reached Penhow Castle, the first building on my list. Through the rain I gained some inkling of how I would tackle this very striking building, but, as it continued to pour down, I decided to leave this subject for the journey back in a day or two.

The weather began to clear in the afternoon, and we headed north for Stokesay Castle, near Ludlow. I had been there on a previous occasion, but was again moved by the sight of it, and could hardly wait to begin a watercolour sketch. As it was still rather wild and blustery, I sat under the lee of a wall to shield myself both from the weather and from tourists, who can be very distracting. I used a hard-backed sketchbook measuring 228 × 280 mm (9 × 11 in), and, with this opened out to make a double spread, I had a space of 228 × 558 mm (9 × 22 in) on which to work.

The weather was not good and I had to work quickly. This was an advantage here, however, as, with threatening skies and fleeting sunshine, the buildings were awe-inspiring, and this was just the feeling that I wanted to convey. My method of painting is to use a lot of water, with periodic washing out at different stages of the drying process, and to blot the preliminary washes with a sheet of clean blotting paper to create a soft effect. For this sketch, I used a very limited palette and worked with large, strong washes, finishing off with a dip pen with a 303 nib and Indian ink. My main aim here was to capture the wonderful drama of the subject, and, when I came to make the finished painting in my studio later, I found my sketch far more valuable than any photograph could ever have been.

AN EXPERIMENT WITH SHAPES

Today, after a hundred years of experimental painting, contemporary art spans the whole spectrum, from realistic painting to a pile of bricks or a completely blank

Stokesay Castle

288 × 558 mm (9 × 22 in)

canvas. There is a great deal of nonsense spoken and written about modern art, but the artist has more freedom than ever before, and art galleries can be very exciting places these days. To my mind, art is all about change, and I am continually looking for development in my studio work (although perhaps not in the more 'practical' sketches and drawings that I make in front of a subject).

The subject of my London painting on page 46 is an imaginative composition from two different viewpoints. As a result of my early training in an architect's drawing office, and the very powerful influence of Italian Renaissance architecture at which I gazed in wonderment as a young man, I have a great love of drawing architecture. I enjoy sketching buildings and cities *in situ* enormously, but I also like to play with the wonderful shapes that they make, in my studio, without the inhibition of having them before me.

For this painting, I stretched a piece of 300 gsm Not watercolour paper on a board and masked off the area that I needed, which measured approximately 265 × 310 mm (10½ × 12½ in). Using a T-square and set square, I drew a grid lightly in pencil over the whole area; this gave me a guide to vertical and horizontal lines for a freehand pencil drawing of the subject. Although the wooden jetties and mooring post play an important part in the composition, they dominated the foreground, and so I moved them further up the river than they actually were, so that they made the perfect foil for the shapes of St Paul's Cathedral and the City in the background. I used sketches that I had made on the spot, backed up by photograph montages, for reference. The jetties have an abstract quality,

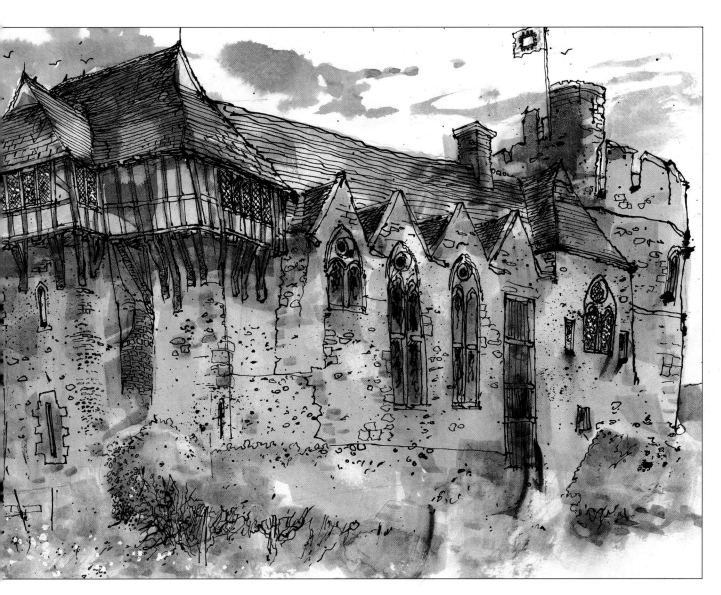

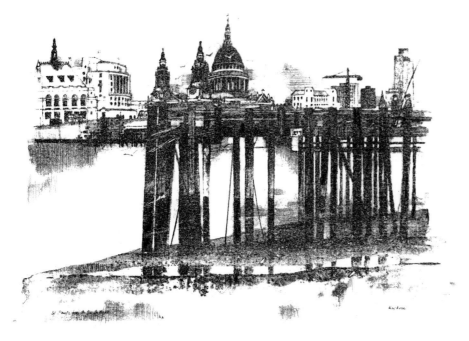

used mixed with water. I used quinacridone red (acrylic) for the sky and water, and washes of cobalt blue, raw sienna and purple madder for the rest of the painting.

With the exception of an early excursion into abstraction, my work has been mainly topographical and figurative. I find it difficult to paint entirely from the imagination, but in my studio paintings in particular I like to take liberties with composition, and to experiment with pattern and shape. I find it fascinating to build up or compose a picture in shapes and patterns, as I did here, by balancing and arranging the different shapes. While I was painting this subject, for instance, the shapes of the wooden jetty cross-members gave me ideas as to how I could develop the abstract qualities that I could see. The faint squares still visible from my original grid also suggested further patterns to me as I built the picture.

The accompanying pencil sketch shown here is a compositional drawing that I made of St Paul's Cathedral, seen behind another jetty from Gabriel's Wharf on the south bank of the Thames.

and I added the two figures to provide a sense of scale, in contrast to the tiny figures on the steps of the Cathedral.

When it comes to colour, other factors emerge, such as tone values, depth and perspective. I used a mixture of acrylics and watercolours for this painting, including Winsor & Newton's watercolour medium no. 2, which gives a slightly greater brilliance and can be brushed out if you wish to withdraw colour from an area. This medium is best

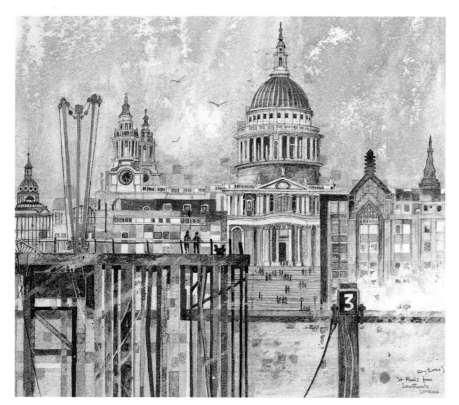

St Paul's Cathedral

265 × 305 mm (10½ × 12 in)

STREET SCENES

I stayed in the teeming capital city of Bangkok on my first visit to the Far East. Conditions there must have changed almost beyond recognition since the beginning of this century, but, as I walked these streets in the steamy heat, I realized that the street life had probably not changed, except that the roads had once been canals and the street vendors would originally have been in boats. Today they ply their trade just as they have always done, despite the fact that the streets are absolutely clogged with buses, cars and vehicles of every description. It was noisy, smelly and steamy when I was there, but more pleasant than it had been for days because the temperature had dropped just below ninety degrees – enough to make the next day's newspapers report that Bangkok was in the grip of a 'cold snap'!

I sat down on an empty bench and got out my sketchpad and watercolours. The secret in this type of situation is to work fast and steadily on small parts of the drawing, before moving on to another part of the scene. Here, the whole street was like a continually changing stage set. The only static element was the cinema hoardings, so I drew these first, and then worked quickly on each small group of vendors. Those who were cooking were fairly stationary, although their customers were constantly changing, but occasionally, just when I was drawing a stall, the owner would pick up the handles and trundle off.

This was one of the most visually

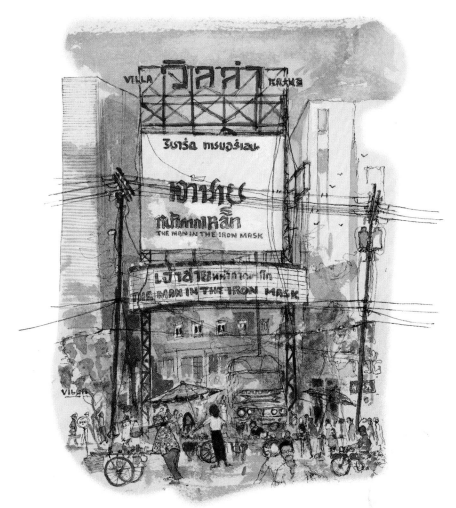

Bangkok
237 × 160 mm (8 × 6 in)

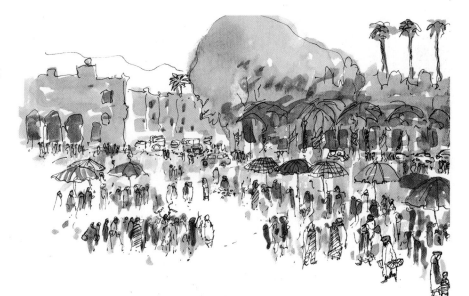

Place Djema el Fnaa, Marrakesh
130 × 190 mm (5 × 7½ in)

satisfying scenes that I had come across during my stay in Bangkok. I had seen, sketched and painted many palaces and temples, but this drawing was about the very life of the place, and, even if the heat, noise and bustle were perhaps not pleasing to Western eyes, I gained more satisfaction from this watercolour than from any other that I was to make in a month in the country. I used a pen line throughout to add definition to the watercolour washes, and to pick out details such as the lettering on the cinema hoardings and the vendor and his stall in the foreground at the bottom left of the picture. As with the traffic sign and bollards in the painting on page 35, I could have omitted the telegraph posts and wires stretching across in front of the cinema, but I deliberately included

these to add to the general sense of overcrowding and city life in the painting.

The small watercolour on page 47 shows another typical street scene. Marrakesh has a wonderful open market which has existed for a thousand years or more, and I made many quick watercolour-and-pen drawings from the second- and third-storey cafés which surround it, drinking mint tea as I worked. This sketch took me only about thirty minutes. I used colour washes to depict both the buildings and trees in the background, and the figures in the foreground, allowing these to merge to create a general sense of the groups of people. I used a dip pen to outline the background features and to highlight the odd car, the umbrellas and some of the figures.

STUDIES IN SPAIN

One tends to think of Spain as a hot, dry country, especially in the far south, but these two watercolours were the result of a very wet and cold week at the beginning of March. I made the sketch below through the windscreen of our hire car because it was drizzling with rain, but managed to park by the road high above the town so that I had a good view.

It was a fascinating scene, set in the mountains near Ronda with an olive orchard in the foreground. Even in the light rain, the white houses with their pink roofs made a

Benaoján

198 × 292 mm (7¾ × 9½ in)

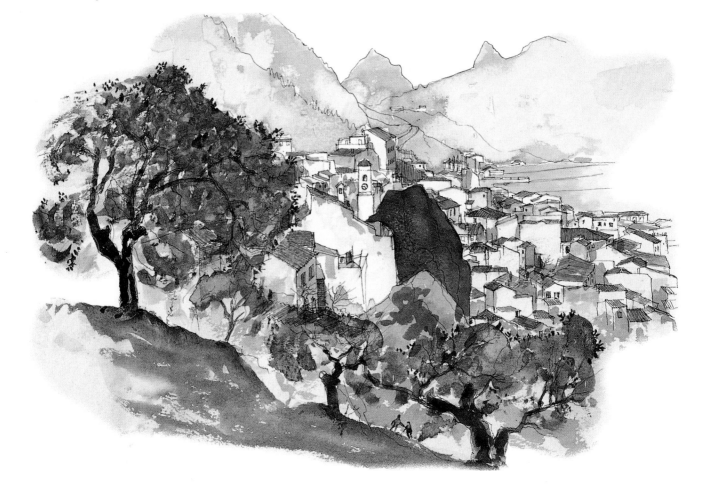

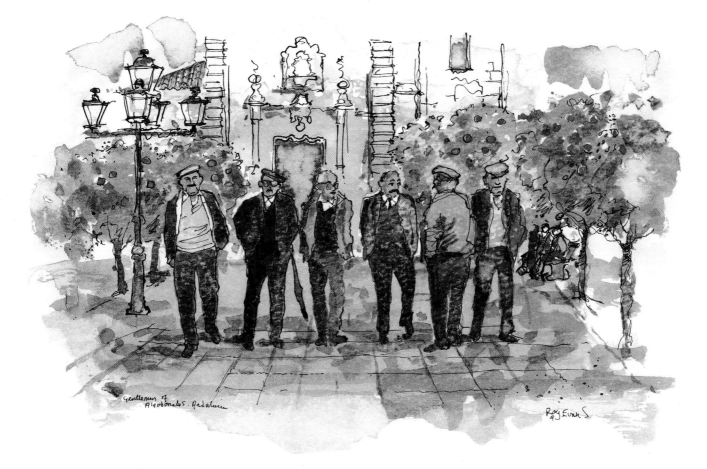

colourful and lovely sight, and contrasted with a great black rock in the centre, around which the town seemed to cling. What interested me most about this subject was the almost geometric precision of the white house against the shapes of the rocks, which I could partly see through the ancient olive trees.

My watercolour took just over an hour. I deliberately tried to work fast, as I often find that the ratio of really successful work seems to drop the more time I take when working on the spot. I finished the watercolour with a fine and gentle pen line to bring cohesion to the whole subject. I left the distant mountains just with a pale wash, as I did not wish them to dominate the scene – in fact, the mountains were unimportant and irrelevant to the composition, except as shapes on the horizon.

The second, smaller painting is a quite different, more light-hearted watercolour that I painted on a Sunday morning in Algodonales. This was a town off the tourist routes, and, arriving there on another damp morning, we felt like intruders, as I suppose we were.

I sat on a bench facing the church, and drew this long line of characters walking towards me. They turned before reaching me and walked slowly back towards the church, then turned again and walked back towards me. This went on for some time, with one person occasionally leaving the group and another joining, which was ideal for me because I had ample opportunity to make this small sketch. What the men were talking about I do not know, but for me they were perfect subjects. I did not want them to know that I was drawing them, so,

Gentlemen of Algodonales

128 × 180 mm (5 × 7 in)

when they got close, I adopted a pensive look and held my sketchbook as though I were writing. I have become very used to disguising – or at least trying to hide – the fact that I am drawing people, so that I can sketch in peace.

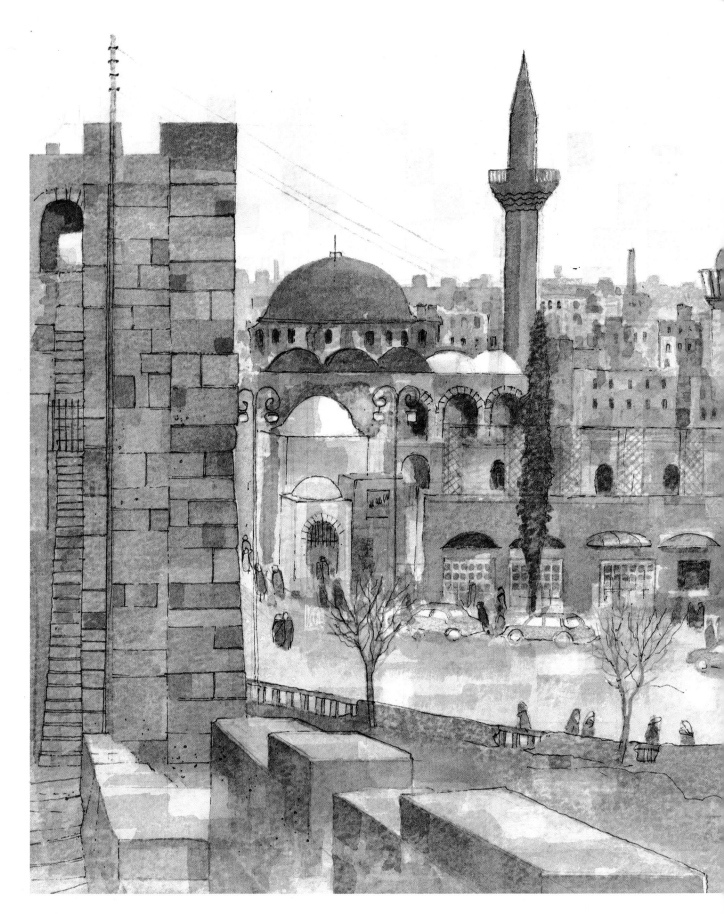

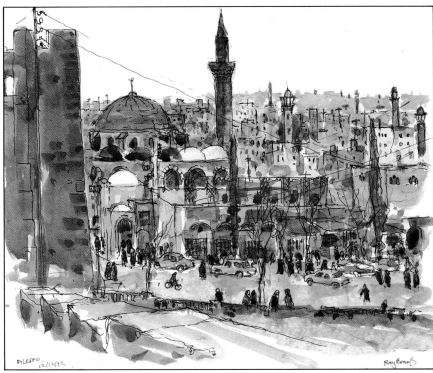

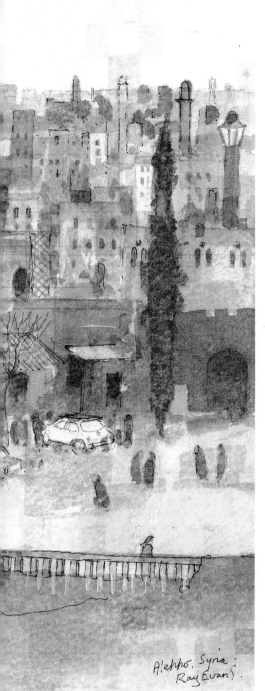

A Journey in Syria

It was very exciting to visit Syria, where my brother's family had lived for many years. We had driven over the desert from the ruins of the wonderful ancient city of Palmyra, and the following morning I found myself on the steps of the citadel in the centre of Aleppo, where the view was staggering. This very ancient city vies with Damascus as the oldest thriving city in the Middle East, and I felt that all the romance of the country was before me. I walked and got lost in the great souk, smelt and tasted the heady atmosphere of Aleppo by walking under and through the city, and discovered that, away from main roads and deep in the souk, this city had not changed a great deal in two thousand years.

Aleppo

265 × 305 mm (10½ × 12 in)

Aleppo

215 × 268 mm (8½ × 10½ in)

I sat on the steps of the citadel, having selected a strongly backed sketchbook measuring 228 × 280 mm (9 × 11 in), with a fairly smooth watercolour paper, on which to work. This paper was reasonably stiff and did not cockle. I chose the watercolours that I needed and squeezed them from tubes into my small watercolour box. I used a half-inch, chisel-ended synthetic watercolour brush and a no. 6 sable brush for the detailed work, and added the final details with a dip pen and Indian ink.

I took just over an hour to complete my sketch, and during that time collected quite a crowd behind me. I was pleased with the end result, and later used the sketch to make a studio painting of the same subject, which is shown opposite.

On the same trip, I visited Palmyra, Bosra and Petra, and

sketched as often as possible. Most of my sketches took less than thirty minutes and generally not more than an hour. I also made constant quick sketches in a pocket sketchbook while travelling by bus. This type of rapid sketching is ideal both for developing drawing skills, and for teaching oneself to pick out the important details in a scene, without including superfluous detail.

Seattle

255 × 375 mm (19 × 15 in)

USA AND CANADA

When I was staying with a friend near Seattle, he took me to the Pacific Fishermen shipyard, where trawlers were being fitted out ready for the fishing season off Alaska. The whole of Seattle seemed to be geared to the great fishing fleet, and the shipyard was full of energy and activity. As soon as I saw it, I was itching to get at my sketchbook.

There was one trawler in particular which interested me. It was a sturdy timber ship built in 1910 which stood in a small dry dock a little apart from the main yard, where it was being re-fitted. I found a quiet place to sit, on a bank of grass under some bushes, where I could work peacefully. I decided that, for this picture, I would not make a preliminary sketch but

would tackle the painting on the spot. I selected a fairly large block of Winsor & Newton 190 gsm Not watercolour paper, which gave me a surface with a little 'tooth' to it.

The boat had a white hull and was being painted deep red below the waterline. Behind it was the great timber-planked wall of a very large boatshed which towered above the boat, while in front of it was another timber fence which echoed the main building. There were some spindly pale trees, still unleaved in early April, some yellow posts, a white post and hosts of seagulls. Beside the area of greenish timber on the left, the hurry and bustle of the main yard created a mass of detail, spars, masts and rigging, which was repeated in the branches of the pale trees and in the masts and rigging of the trawler.

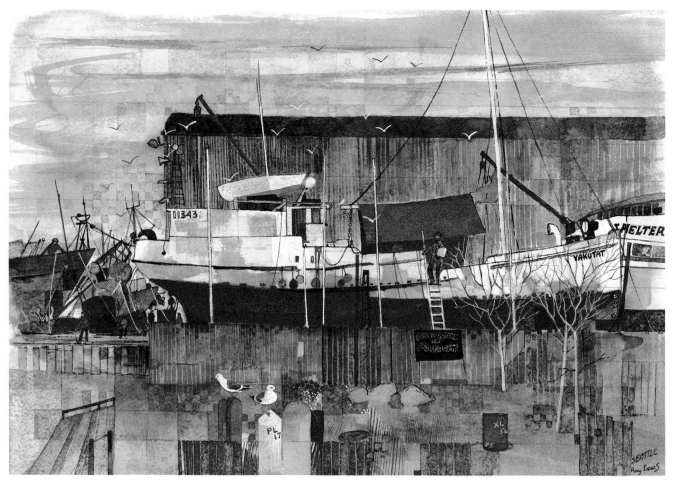

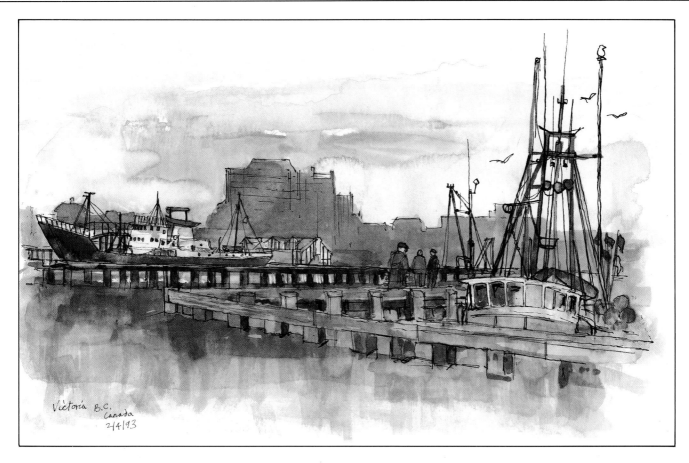

Victoria B.C.
Canada
2/4/93

I began by drawing a few quick lines in pencil as a guide, and then started to paint using just a few watercolours and three brushes: a no. 6 sable, a smaller sable and a larger, square-ended brush for the washes. I also kept a clean sheet of blotting paper handy to blot out the preliminary wash colours to keep the tones subtle. I worked for two hours, aiming to get the wonderful red of the boat just right, completing the pale sky and drawing in a lot of the detail. What fascinated me most were the bright colours: the red of the boat, and the blue cover draped over the boom. The repeated vertical planking was also a special feature, and brought the different elements of the picture together.

I did not touch this painting again until I was back in England. I stretched the paper on to a drawing-board to prevent cockling (this is easily done with an unfinished painting if you are careful). I then started to paint in earnest, and finished the picture after about five hours. Blues were a strong feature of this painting, and I used Antwerp blue, permanent blue, blue-black, cobalt blue and turquoise, as well as mauve, new gamboge, chrome orange, rose doré, permanent rose (quinacridone), rose carthame, sap green and white. This may seem a considerable number of colours for one painting, but, when I am in my studio, if I need a particular colour or hue, I will use it straight from the tube rather than mixing to achieve it, and this keeps my colours strong and clear.

I became engrossed with the pure geometry of this subject, and greatly enjoyed playing with shapes and colours without being inhibited by having the actual subject before me. The inspiration was there in my preliminary work done on the spot.

Victoria

175 × 290 mm (7 × 11½ in)

The week before I made this painting, we had taken a fast ferry up the coast to Victoria on Vancouver Island in Canada. I made the sketch shown here in Victoria harbour in fifty minutes before rain set in and prevented me from working further, but I felt that I had captured the feel of the subject quite successfully.

A Long Look

Hastings is an ancient historic town in the south-eastern corner of England. It is a working town with a line of fishing boats drawn up on the shore, and fish are still sold in the little shops and shacks near the tall wooden fishing lofts. Before the advent of nylon, the lofts were used for drying fishing nets, but are still used for storage, and stand in serried ranks at right angles to the shore. Among them is the fishermen's chapel – now a museum – standing white and stark.

The whole scene made one of the most visually exciting places to sketch and paint that I have ever found. The shapes of the lofts, in their dark colours, stood bold in the landscape, and the pale chalk cliffs and the town itself made the perfect backdrop to both the buildings and the boats. As I walked around I felt a sense of the timeless atmosphere of the place, which I have tried to express in my painting.

I used a 2B pencil for the pencil drawing shown below, which is just soft enough to make a good, dark line without smudging, provided that you work carefully and keep the pencil well-sharpened. I also find it useful to place a piece of blotting paper under my hand to prevent smudging if I need to work over part of a drawing at a later stage.

I drew the line of boats along the shore, and then, turning my seat, drew the cliffs and the fishing huts behind the left-hand boats. This was the type of composition that I wanted, and, in the studio later, I painted the watercolour shown here, which was based on (but did not follow exactly) this sketch.

Remember that you are making and composing a painting, not taking a photograph, and this gives you the freedom to alter different elements to suit the overall composition. In this scene, for example, the huts were not in fact behind the boats along the shore, as I have shown them, but that is really a mere detail and my composition is still very much Hastings.

I used acrylics on white card to capture the bright colours of the scene in my studio painting. I composed this picture from many aspects of the subject, and took considerable licence with the placing of the boats, the fishing huts and the white chapel, as you can see by comparison with the more 'accurate' pencil sketch. Once again, this is an example of feeling free to adopt a subject in this way in my studio, without having it in front of me.

I felt that this was one picture which came off very well, and made me completely satisfied from start to finish. As with many artists, for my best paintings I have to feel really excited about the subject and the composition, and, when this happens, the results are greatly enhanced. Some pictures of course are unsuccessful, and this happens to all artists, but I look on this as a positive experience, because if painting becomes too easy it somehow seems less worthwhile.

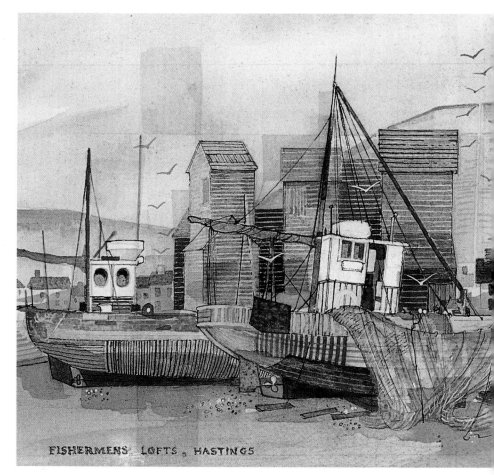

FISHERMENS LOFTS, HASTINGS

Hastings

205 × 470 mm (8 × 18½ in)

Hastings

115 × 270 mm (4½ × 10½ in)

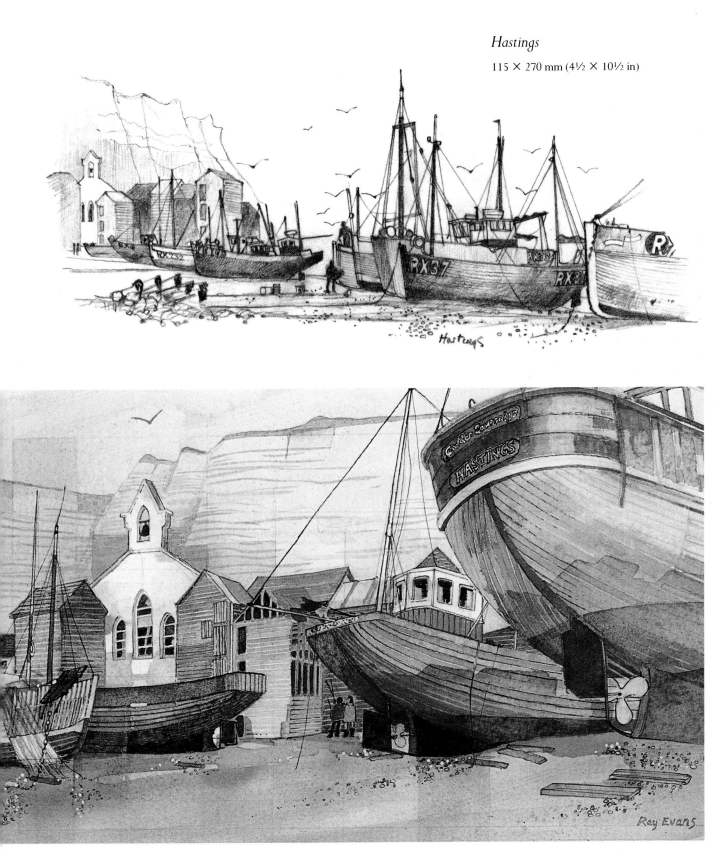

HASTINGS

I returned to Hastings last year and made a new series of drawings and sketches of the same scene. I became even more fascinated by the boats on the shore, with their great whale-like hulls and the contrasting vertical shapes of their masts and rigging, as well as by the flags on poles which mark the position of the lobster pots or nets when they are left at sea.

I painted the little watercolour shown below in my studio, based on a collection of pencil and line drawings plus numerous photographs taken on the spot. I was intrigued by the patterns that the boats made, and by their different colours. I used a fairly strong wash of cobalt blue for the second boat in the row, and echoed this in areas of the left-hand boat and on the flags and oil drums in the foreground. The shadowy figures working on one of the boats give a sense of perspective and activity.

For my second painting, I picked out a blue boat which pleased me and made a drawing and took six photographs of it from various angles. I decided to let the blue of

this boat permeate the whole picture. I decided on a squarish format for the studio painting, and selected a sheet of Bockingford 300 gsm watercolour paper. The watercolours that I used consisted of a number of blues – manganese blue, cobalt blue, azure cobalt and cerulean blue, as well as permanent rose, mauve, a little black and some chrome orange for the boat at the top left of the picture.

There were some strips of wood, painted bright blue, drying on a plank in the foreground on the gravelly sand. These made a perfect foil, and I used them to accentuate the perspective and to echo the planks under the keel of the boat.

I made the horizon high so that the masts and rigging were at the top of the picture. I cut the shape of the boat with two vertical flagpoles in the foreground, so that the left-hand pole split the composition roughly into two-thirds and one-third vertically. I am a great believer in dividing my compositions into proportional shapes in this way, in order to establish a harmonious balance. In this case, the right-hand pole also splits the picture in

approximately the same proportion that the horizon splits the horizontal plane, creating a satisfying result.

As I have already mentioned, I will use as many watercolours as I need in a painting, so that I can achieve the effects for which I am aiming. Although the initial outlay for a number of paints may be expensive, it really is worth making this investment if you possibly can, as the colours remain so much clearer and more transparent if you can find the right colour in a tube rather than immediately dulling the colours by mixing them. By using pure colours, you can lay them across each other to give beautiful changes of hue without losing much transparency, which is really the essence of watercolour. This applies particularly to paintings carried out in a studio, rather than to sketching on the spot, where the colours that you carry with you may often be limited for practical reasons.

Old Hastings

78 × 175 mm (3 × 7 in)

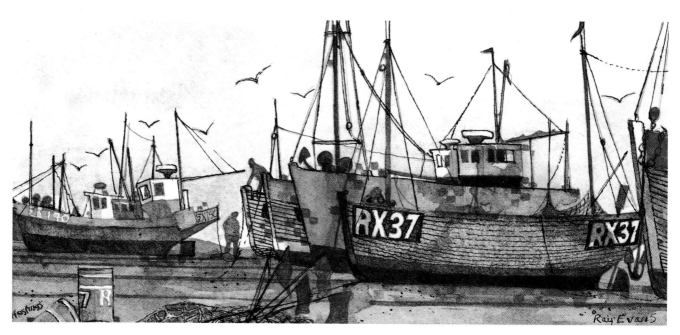

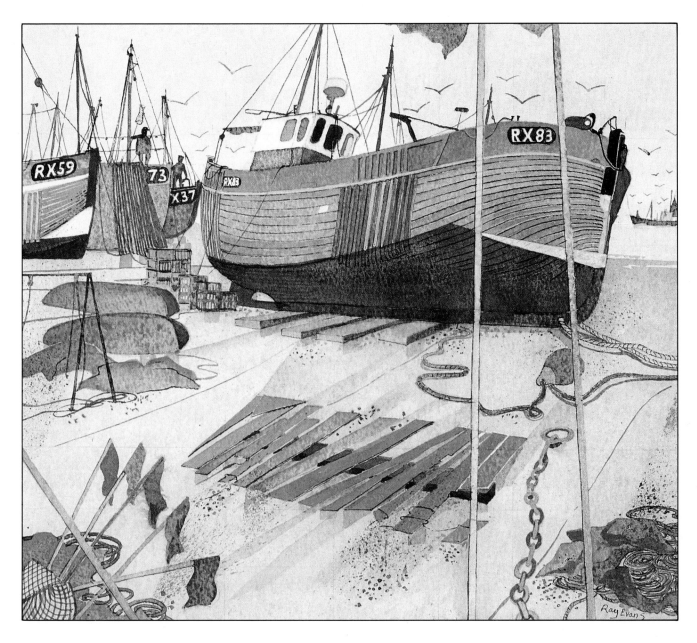

In this painting, I tried to keep the shore light in tone, like the sea, and to make subtle changes of colour relating to each other. As I often do at the start of a painting, I use a clean sheet of blotting paper as I laid in the preliminary colours, to blot out and keep the tones subtle. I painted in the contrasting dark tones at a later stage. I use a range of brushes, including various square-ended synthetic brushes for the washes, and smaller sable brushes for more detailed work.

Old Hastings

265 × 305 mm (10½ × 12 in)

Moira Huntly

It may seem strange, and perhaps even a contradiction in terms, to say that I paint most of my landscapes indoors. These are not imaginary landscapes, however, but paintings derived from many drawings, colour sketches and information that I have gathered on the spot from direct observation. Since my student days, I have always believed in direct observation as a means of gaining a wealth of knowledge and a feel for colour and form. Some colour I can remember, but some I need to record.

In looking at a landscape, I am endeavouring to discover something to which I can instinctively respond, and this is not necessarily the obvious 'pretty' scene. For instance, I can recall driving through Snowdonia and over the Denbigh moors one autumn evening. The sunset was wonderful, the light magical, the scenery spectacular, and I was listening to a tape recording of Grieg's Peer Gynt Suite. It was one of those perfect but brief moments in time that I will always remember, yet I felt no desire to stop and paint.

In other words, I can admire and be overwhelmed by the beauty of a landscape without wanting to paint it. I am more likely to feel a powerful desire to draw or paint the complexities of an industrial coal-mining landscape or a busy harbour, or the angular, dramatic rock shapes of a rugged coastal landscape. These are places that I like to paint, probably because they fulfil the visual patterns to which I respond.

I work in a variety of media, but, whichever medium I use, my way of thinking and general approach to a painting remain the same. I am seeking complex images, and looking not at a landscape as such but rather for visual patterns, design and shape, and in particular for the abstract shapes that appeal to me. In my paintings I try to combine the abstract patterns that I have perceived with a realistic interpretation.

Drawing is very important to me. I try to observe with accuracy, and, in so doing, to see the subject more clearly and to discover its potential as a starting point for a painting. I generally know fairly early on whether a subject is going to work for me and will provide enough visual ideas. My sketchbooks have accumulated over the years, and these provide me with a fund of information.

(Opposite above) *Chelsea Embankment, 1951*

182 × 255 mm (7¼ × 10 in)

(Opposite below) *Chelsea Embankment*

560 × 740 mm (22 × 30 in)

CHELSEA EMBANKMENT

It is sometimes interesting to return to early work for inspiration, as I did with the sketch shown here, which I made on Chelsea Embankment in my student days. I was intrigued by the 1951 date on the sketch, and gratified to find qualities in the drawing which attracted me into making a painting so many years later.

The treatment in the sketch is very direct and uninhibited, with bold ink work applied with a brush to give combinations of line, dry brushstrokes and solid areas of black.

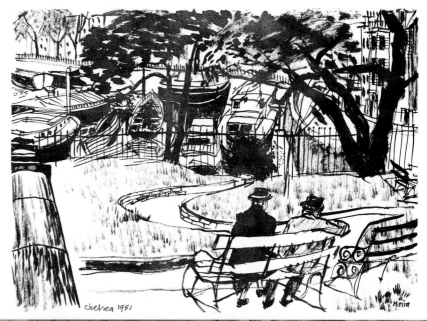

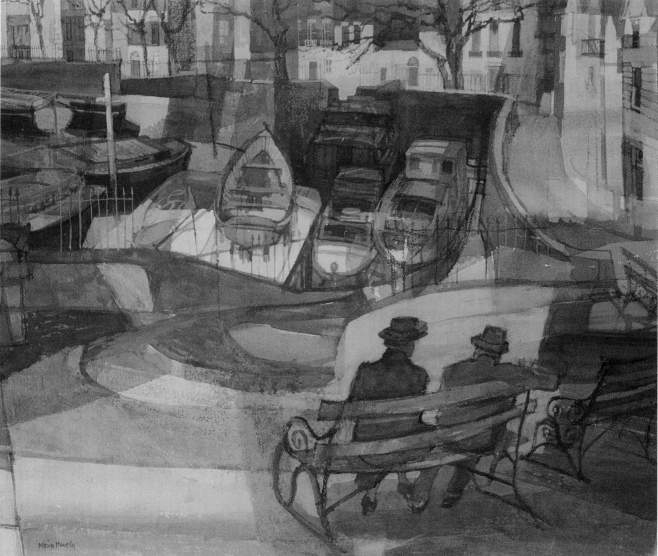

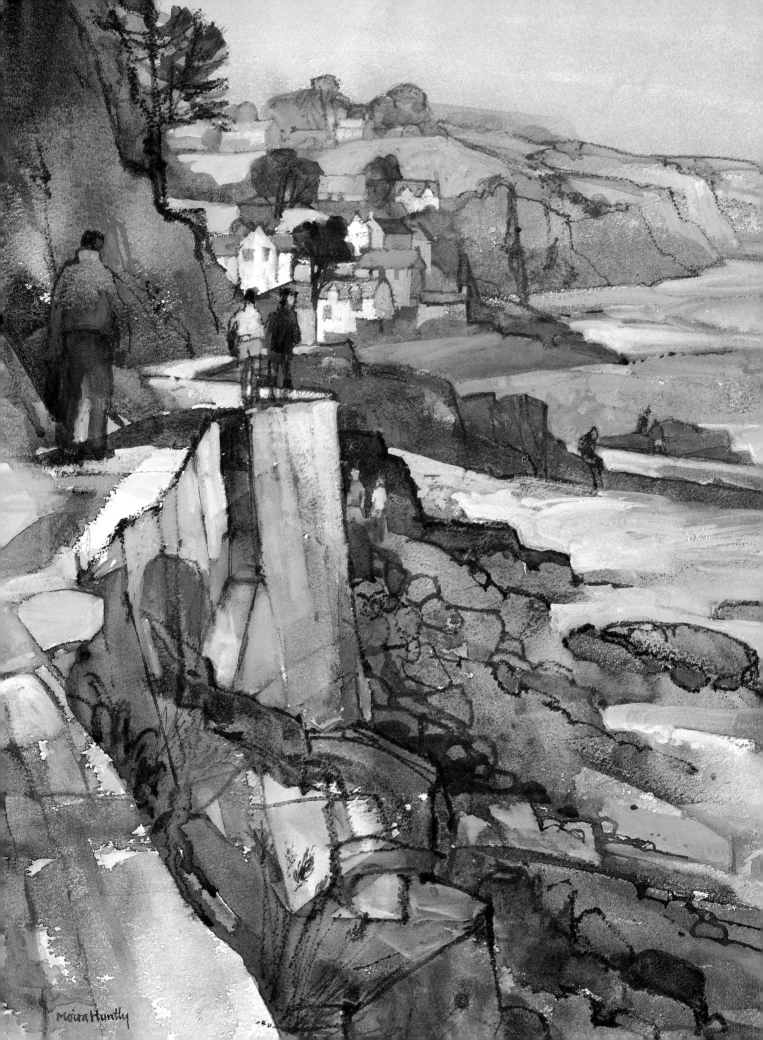

Analysing this sketch now, I am interested in the distribution of the black areas, the top half containing a preponderance of black with small areas of paper untouched, while the lower half has one solid area of black in the seated figure. I also notice that, within the overall spontaneous, almost youthful, aggression, there are small areas of precise drawing, particularly on the boats.

In the painting that I made from the sketch, the areas of dark and light are distributed differently, with a large mass of dark tone in the top left half of the painting balanced by a smaller area of dark in the opposite corner. There is also a balance of lighter-toned areas which are golden in colour, again dramatically opposite each other. It is interesting that the painting gives much less importance to the trees than the sketch, and is more concerned with an arrangement of fairly abstract foreground shapes, within which are the few literal details of figures and boats.

CLIFF WALK, PEMBROKESHIRE

This coastline is dotted with small bays, rocky foreshores and small farms perched above steep cliffs, and my sketchbooks are full of such subject matter. I made this painting in the studio from a black-and-white sketch, aided by a deep-rooted memory of the place.

I was impressed by the flat slabs of rock, some of which echoed the rectangular shapes of the houses. These contrasted with the more rounded jumble of the boulders,

Cliff Walk, Pembrokeshire

505 × 400 mm (20 × 15¾ in)

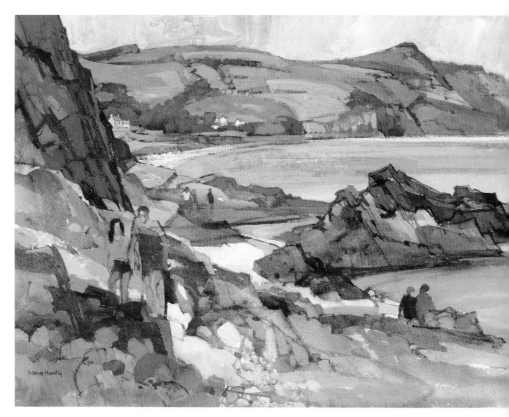

which seemed to tumble down towards the sea, diminishing in size and finally merging with the grains of sand. I clearly remember the patterns of distant fields, punctuated by rounded blots of trees, and, above all, the pattern of light and shade.

The paper that I chose for this painting had a rough, strongly sized surface. The size bubbled through the very wet washes of blue in places to create a speckling of white, which enhances the impression of a sparkling, sunny day.

PEMBROKESHIRE COAST NEAR AMROTH

This painting was also made in the studio from a quickly executed pen-and-ink sketch. Looking at a sketch can often trigger off a memory of the atmosphere of the day, and this can unconsciously influence the colour and mood of the painting. This area of coast is a favourite haunt of mine,

Pembroke Coast near Amroth

405 × 560 mm (16 × 22 in)

and I like to visit it in the late spring, just before the holiday season starts, when the beach is uncrowded. The mood is quiet, the light soft and the colours subtle.

I considered the subject in terms of warm sand colours and various greys. These greys contained occasional touches of blue and mauve, and the sand colours also had variations of ochre and brown. I tried to render the whole surface of the painting in a kind of mosaic of these colours, interspersed with patches of cool – almost white – light. The problem here was to achieve a broken-patterned surface without allowing it to become 'bitty', and this entailed constant adjustments of colour and tone.

This process was helped by following my normal way of

working, starting with transparent
washes of colour and gradually
modifying these in places with
gouache. As well as helping to adjust
the initial colours, these areas of
semi-opaque gouache provided
subtle changes of paint surface, in
contrast to the transparent areas.
I am very much concerned with
this in my painting process, which
begins with laying in the subject in a
broad way using transparent colour
and a two-inch-wide house-painter's
brush, rather than with a carefully
produced outline drawing. I
continue the work with more washes
of transparent colour, which I then
develop by drawing into them with
small brushes and modifying the
forms with gouache.

North Wales, Working on Location

As I have already mentioned, I
produce most of my paintings in the
studio nowadays, based upon
drawings made on the spot, but
every now and then I like to return
to painting out of doors. I find it
good to replenish my knowledge in
this way, and to refresh my vision of
the landscape with the close contact
of direct observation. Painting out
of doors is not always easy, and
presents many practical difficulties –
the worst of these being the weather,
particularly in Britain.

I was unable to finish my painting
of Cesarea in North Wales because
of the onset of rain, but I was able to
capture something of the atmosphere.
I used transparent watercolour and
gouache on grey pastel paper for this

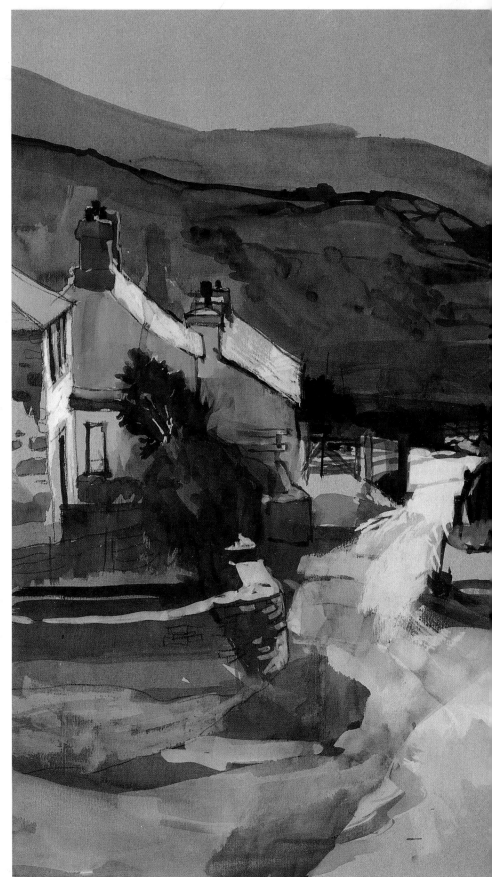

Cesarea, North Wales

480 × 640 mm (19 × 28½ in)

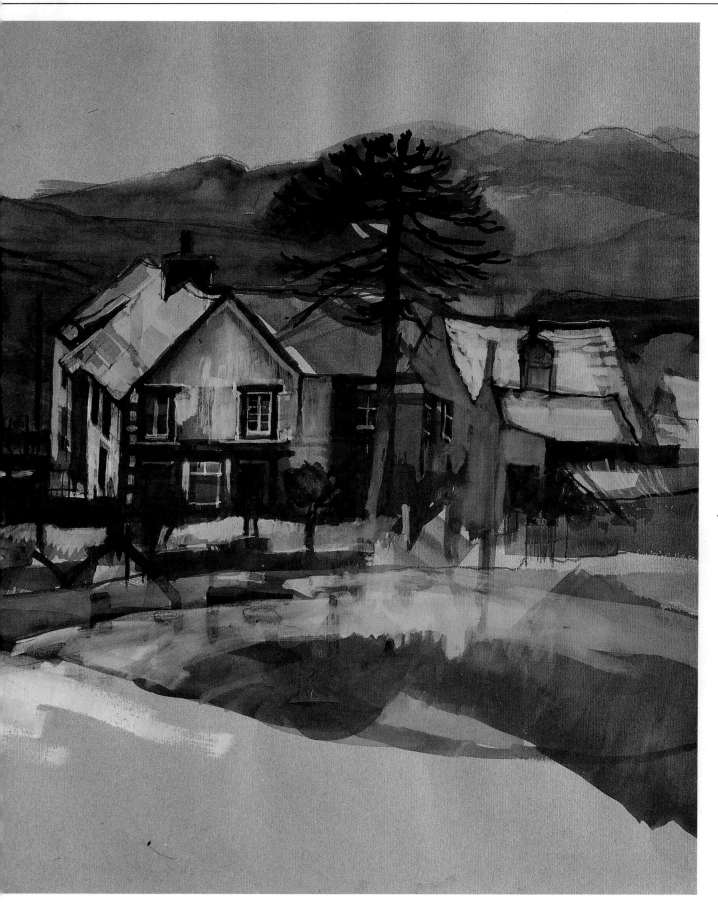

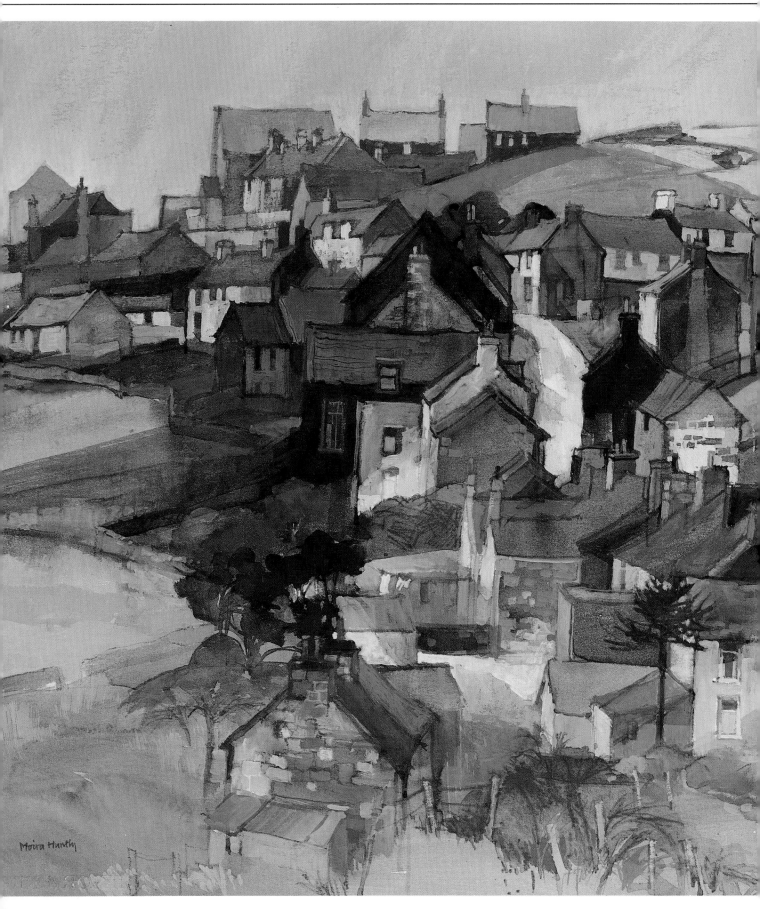

Llithfaen, North Wales

260 × 405 mm (10¼ × 16¼ in)

LLITHFAEN, NORTH WALES

Another of my favourite villages in
this area is Llithfaen, which
straddles an undulating part of the
road and provides many interesting
viewpoints. I carried out several
drawings from different positions,
including this working sketch with
the road leading up to the cottages,
which I made while seated rather
precariously on top of a wall. I
gained some comfort by sitting on a
foam cushion in a plastic bag to keep
out the damp – an ideal alternative
when a sketching stool is impractical.
I recorded the variations of colour
and tone on the roofs and chimneys,
which had attracted me to the group
initially, with felt-tip pens. These
are not a permanent medium as the
colours fade over time, but they are
quick and easy to use for a sketch
intended for reference only.

I based the painting on a drawing
that I made from a high vantage
point encompassing the whole
village and looking across the valley,

painting. I chose initially to work on
tinted paper out of doors in order to
counteract any glare from the sun,
but the grey of the paper also lent
itself well to the subtlety of the
landscape on this overcast day.

Cesarea is a small hamlet at the
head of a valley. The road
terminates in a huge blue-grey slate
quarry before continuing as a narrow
track up into the mountains. Blue is
everywhere – in the stone walls
enclosing small patches of blue-
green grass, in the houses relieved
occasionally by pink- and once-
white-painted walls, and on the
polished slate roofs, damp and
glistening, which reflect the sky
above. I emphasized the light tone
of the road, in relation to the tones
elsewhere, partly because it appealed
to me to lead the eye to a corner that
invites you to wonder what lies
beyond, and partly because it
provided an area of contrasting tone
in the design of the painting.

Llithfaen, North Wales

530 × 670 mm (21 × 26½ in)

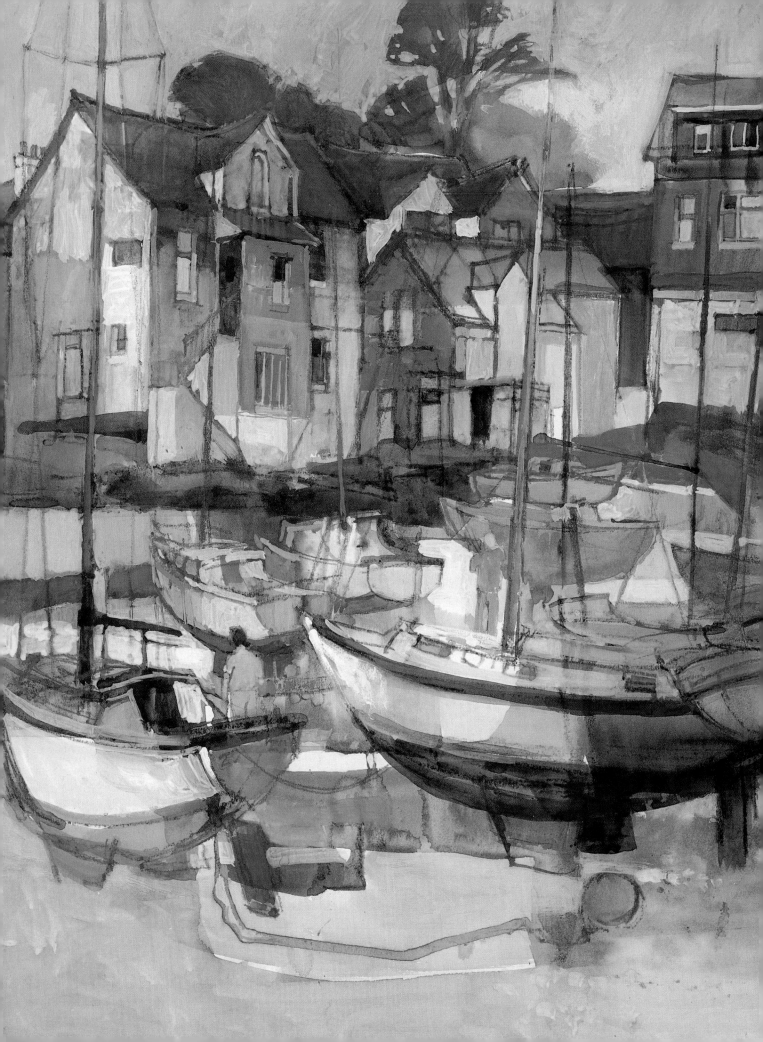

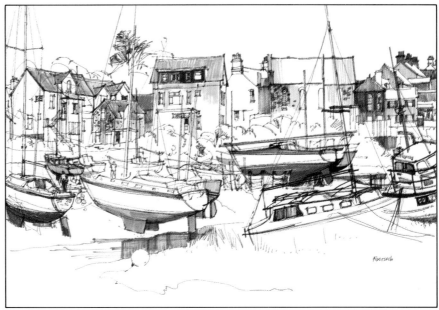

Abersoch

405 × 495 mm (16 × 19¾ in)

with my eye level towards the top of the drawing. A good viewpoint is important to me, and my instinctive preference is for a landscape which is not flat. I like intimate, hilly, rising ground, preferably with buildings which form an integral part of the landscape.

This is a fairly large studio painting, made on 300 lb (640 gsm) Not (cold-pressed) watercolour paper. I began by broadly indicating the main shapes with transparent washes of cool colour. I visualized the road as the lightest part of the work and placed it centrally in the painting, offset by echoing accents of light on some of the buildings. I registered the other buildings mainly in low tones, which blend into the dark ground washes. This simplification knits the buildings together as one mass, but gives the impression of individual houses. The cohesion is also helped by the repetition of blue.

The darkest tones are in the area

surrounding the highlighted road. It was important to give an impression of the road climbing steeply upward and away from the village, and I did this by using the maximum contrast of dark and light high up in the composition. As a result, the foreground only suggests a few features, and the tones are closer.

ABERSOCH

Abersoch is a popular and rather crowded sailing resort on the Lleyn Peninsula in North Wales, and its harbour and estuary are full of colourful boats and activity. I like to visit seaside towns and villages in their off-peak seasons, when the intrinsic character and atmosphere of the place are more easily observed. This marine-scape is full of variety. The buildings around the harbour are all different; there is a jumble of boat shapes, lots of detail, bushes and trees, and a couple of

Abersoch

500 × 530 mm (19½ × 20¾ in)

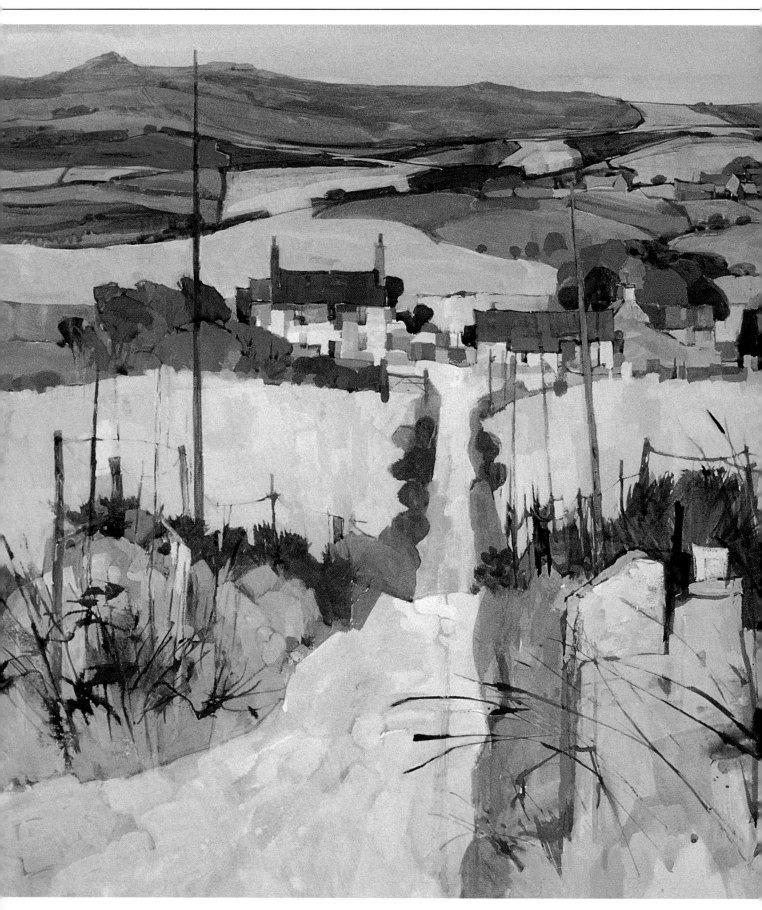

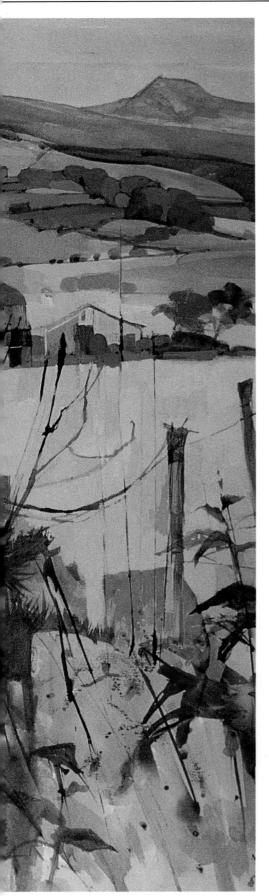

figures give scale and life to the sketch.

I completed the drawing fairly quickly but, even so, I considered the proportions of the various components carefully before putting them down with rapid, decisive strokes of my drawing pen. I was attracted to the row of buildings in the background, and by the position of the boats across the beach in a line parallel with them, their masts cutting vertically across the buildings. I indicated a few reminders of local colour, using felt-tip pens, as a few colour notes of this kind are often helpful for a future painting. In the event, my painting has only partially been influenced by the colour notes on the sketch.

I like low water, when boats are high and dry and the shapes of keels and rudders can be seen. I focused the foreground of the painting around this aspect of the subject, and this led to selection from the horizontal format of the sketch to produce a painting that is almost square. I find it easier to explore compositional ideas when I am painting in the studio, rather than on the spot, where there is always the danger of objects 'taking over' so that I begin to lose some of my initial abstract ideas.

THE GINGER ROOF

This painting also shows part of the Lleyn Peninsula in North Wales, where the landscape has a calm, pastoral atmosphere. The buildings here are in harmony with the landscape, enlivened by the accent of the ginger-coloured roof and by

The Ginger Roof

455 × 620 mm (19 × 25 in)

the light strip of road, which leads the eye vertically to that centre of interest.

My preliminary sketch for the painting (not shown here) had fairly detailed drawing in the foreground, and this is reflected in the emphasis of foreground shapes in the painting. The middle distance is seen between some of the nearer plant forms, and spiky plants and vertical posts cut across the yellow-green field, linking the foreground with the distance.

I can remember that there was a variety of warm and cool greens, and, beyond the road, an area of soft, pale green, zig-zagging into the distance and leading the eye towards a more remote group of farm buildings.

FARM AT TRETIO

My impression of Pembrokeshire is of an ancient land, windswept and desolate in places, but perhaps I have this impression because the elements have so often been unkind to me whenever I am sketching in that part of the world. In my drawing of the farm at Tretio, I see a certain wildness. The line has a vigour and movement which helps to create the impression of a village on high ground, where the trees appear to lean as they catch the prevailing wind.

The main interest recorded in the sketch lies in the buildings and trees of the middle distance. Unlike the sketch for *The Ginger Roof*, I kept the foreground detail to a minimum here. Later, when I interpreted the sketch as a studio painting, the direction and placing of these few lines was to play an important part in my painting of the foreground.

In the painting, there is a variety of greens: yellow, blue and grey

69

greens, soft brown and olive greens, and here and there small, vivid, bright patches of acid green, all painted over a warm wash of raw sienna. Some of this initial warm sienna wash also flickers through the subtle colour of the sky.

This landscape is one of hilly banks, hollows and folds, and the undulating, ribbon-like road leads us into the farmyard. Here the buildings seem to have stood for years, and old stone walls to have grown in harmony with their environment, so that they belong to the landscape.

The few brief, simple lines in the foreground of the sketch inspired a feeling of movement in my painting of the long grasses and bracken,

forming almost a groundswell of brushstrokes. I like to exploit patterns of tonal counterchange, and here I depicted trees and some buildings darkly against the light sky, while other buildings are light against dark trees. Some areas are less contrasting, such as the central barn, where the dark roof is close in tone to the trees.

HOLYHEAD

I found this cluster of shoreline buildings, protectively surrounding a small rocky harbour, at Holyhead on the north coast of Anglesey. I liked the reassuring feeling of enclosure against the elements. It was a calm day when I made the sketch, and I have echoed this

(Below) *Farm at Tretio*

370 × 560 mm (14½ × 22 in)

(Above) *Tretio*

296 × 405 mm (11¾ × 16¼ in)

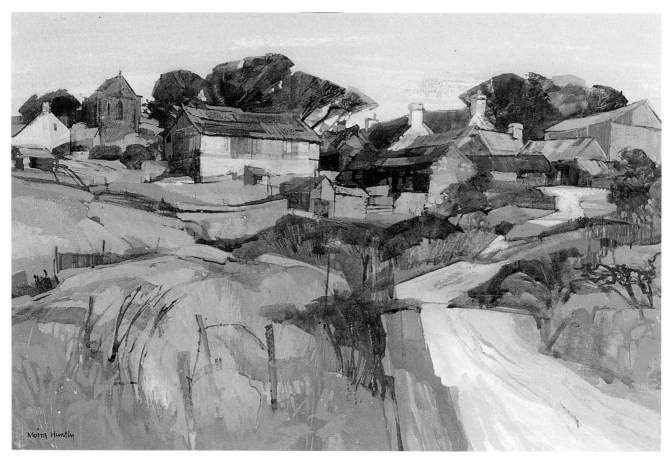

subconsciously in my subsequent studio painting. The colours are soft and subdued, the brightest accents being on the coral-coloured cottage and the touch of pale blue on one of the boats.

In studio surroundings I find it easier to interpret a sketch in my own way, sometimes deliberately imposing a limited colour scheme, or perhaps exploring the interaction of complementary colours. In this instance, the emphasis was basically the interaction of orange and blue, but played down to very subtle relationships within a limited range. I interpreted warm orange in a low key represented by earth colours, tan, and, at its brightest, coral. Similarly, I depicted blue at its brightest as very pale, and mostly represented by Payne's grey. I introduced a little olive green as an intermediary between the warm and cool colour range; this kind of subtle interplay helps to give unity to a painting.

I began the painting with wet-in-wet washes, then superimposed the drawn details with a brush, varying the colour and tone of the line throughout. I achieved some of the textured line work by drawing with a stick dipped into moist watercolour. The water reflects the sky, and incidental washes create a feeling of dappled light from a watery sun shining intermittently between passing clouds.

Although this is a straightforward figurative painting, there is also a strong element of design. The distribution of darks is important, and the dark olive-green shape of the hull of the foreground boat is balanced by the olive-green square and rectangular shape of buildings. The extra-dark 'blob' of the tree placed in front of one of the cottages, and emphasized by the light walls, became an important shape, balanced by a distribution of

Holyhead

295 × 820 mm (11½ × 32¾ in)

dark doors and windows. I interpreted these, in turn, as a simple pattern of emphasis, rather than as a totally literal rendering of each detail. The tan-coloured roof in the shadows provided a touch of relatively more intense colour among the surrounding subtle colours; there was no need for it to be any stronger in the context of this painting.

The long, narrow format of the painting makes an important contribution to the overall concept by enclosing the narrow shapes of the boats, roofs and the long strip of rock. I emphasized this effect by running the cottages out of the left-hand side of the painting instead of showing them as a whole, as I had done in the sketch. There is far less sky in the painting, and the whole arrangement is compressed into a long, narrow sandwich.

Holyhead

195 × 530 mm (7¾ × 20¾ in)

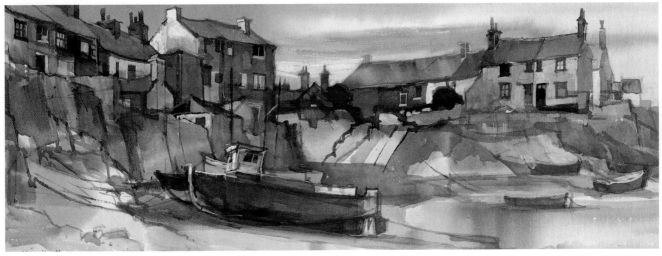

Anglesey

Skirza
Caithness

Granada

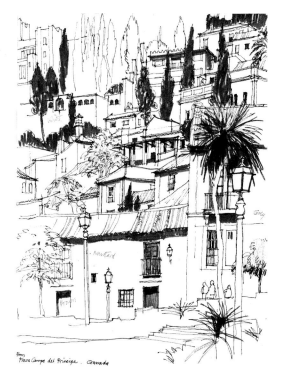

From
Plaza Campo del Principe . Granada

This is a random selection of
sketchbook drawings.

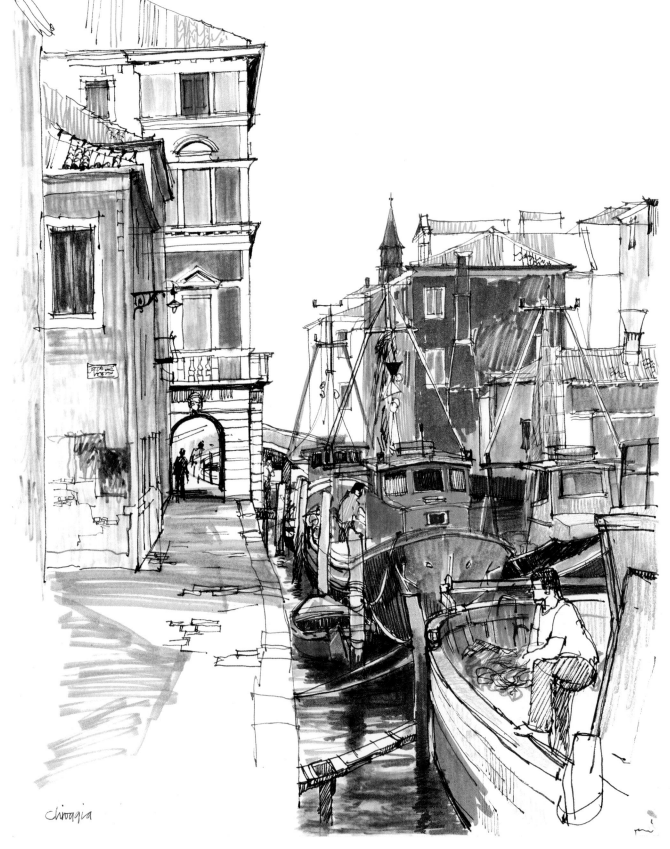

Chioggia

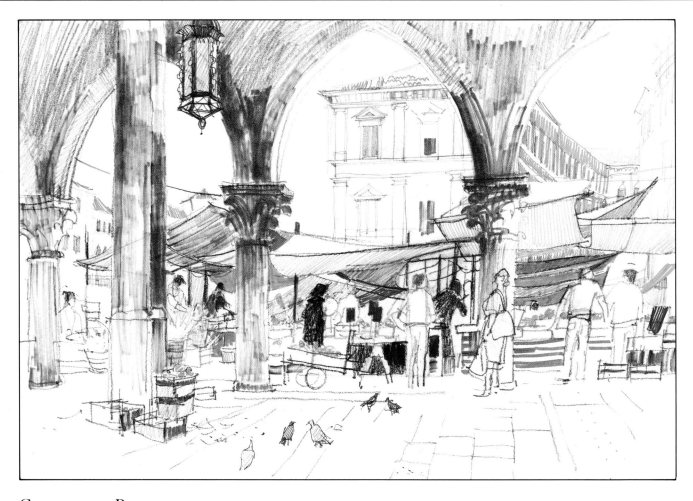

CAMPO DE LA PESCARIA, VENICE

Venice is one of the most visually exciting cities I have ever visited, and in the few days that I was able to spend there I worked feverishly to record as much information as possible. I made this sketch *in situ*, using a combination of black conté pencil and felt-tip pens. Some of the latter were reaching the end of their life, and I chose them deliberately so that the marks they made would be broken and not too dense.

The scene was one of activity in the busy shopping area of the fruit, vegetable and fish markets. The produce was piled on wooden portable stalls, in crates and on wheeled carts, all under colourful awnings slung from ropes and poles. I showed some of the figures in silhouette and just suggested others in outline, drawing rapidly as people paused briefly and then passed by. The inevitable pigeons strutted around with watchful eyes, alert to any discarded tasty morsels.

The arched openings are valuable components of the composition, but could easily have been too powerful and dominant. I prevented this by concentrating the strongest tone at the top of the columns, working in felt-tip pen and keeping the arched parts in open, lighter-toned conté pencil.

My studio painting follows the sketch fairly faithfully. I began this with washes of transparent Hooker's green watercolour, to create cool shadows and to establish the bright green awnings which had been the initial attraction of the scene. I gradually muted this strong colour

Campo de la Pescaria, Venice
296 × 405 mm (11¾ × 16½ in)

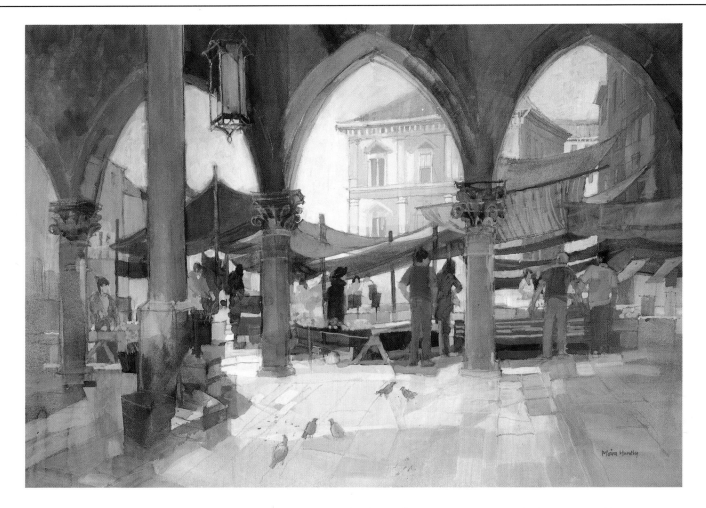

Campo de la Pescaria, Venice

440 × 635 mm (17½ × 25 in)

basis with gouache, which I applied opaquely in places and in semi-transparent milky washes elsewhere. The use of partly opaque washes emphasized the transparency of the watercolour washes, and consequently helped to heighten the impression of light flooding the background buildings and the paving in the foreground.

I superimposed line work over the washes with a small sable brush and with soluble watercolour pencils. I have taken to using watercolour pencils fairly recently, and find the subtle 'lost-and-found' quality of line that can be achieved over wet and semi-dry washes very pleasing in its effect.

As in the sketch, I attempted in the painting to keep the interest with the awnings and with the pattern of strong light around the dark figures.

I deliberately made the arches slightly less dark, and only hinted at most of the foreground shadows. The vertical column on the left is useful in breaking the uniformity of the arches across the painting but could easily have been too powerful, so I painted it in a fairly high tonal key to avoid that.

HOTEL SAFIR SIAHA, MARRAKESH

I visited Morocco in March, when the daytime temperature was not too hot and I could comfortably sit outside to draw. It is a fascinating country, with extreme changes of landscape from desert sand to high, snow-capped mountains, and from Moorish architecture to exotic

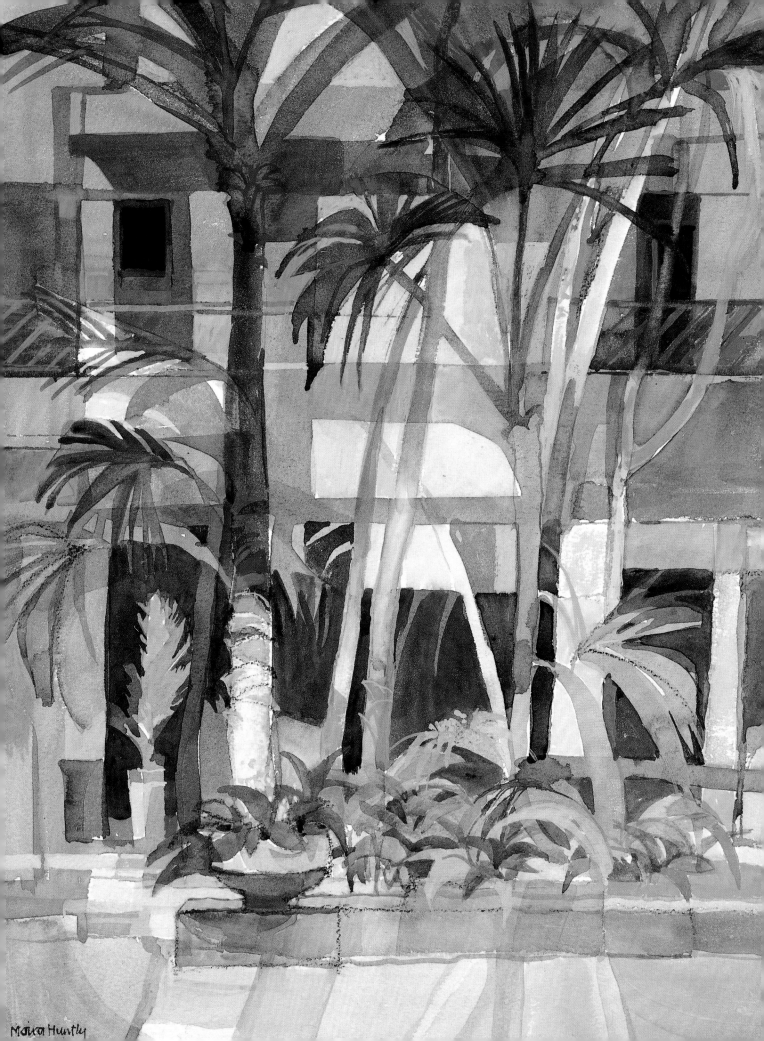

Moira Huntly

fauna. The gardens in Marrakesh are full of shady palms of all shapes and sizes, some with a giant leaf spread. There are fleshy succulents, large cacti and lemon and orange trees, whose abundance of growth is quite surprising for a country which can become very hot in the summer months.

This particular group of palms and the pattern of shadows against the building caught my eye. I made a pen-and-ink drawing to capture some of the elements of design and shape, concentrating particularly on the palm leaves fanning out in circular motions, in contrast to the vertical shapes of the trunks and doorways.

A considerable time gap had elapsed in the studio between my painting of Venice (page 75) and this painting of a Marrakesh hotel garden, but it was interesting to realize that I had chosen green as the dominant colour in both cases. The Hotel Safir Siaha was in fact typically Moroccan, with its pinkish-red walls and deep-green painted railings and doors, but I remember the subject in terms of cool blue and green shaded areas, with patches of strong, creamy-coloured sunlight. These colours are distributed in the painting as a rectangular grid, in front of which the palm trees form vertical elements which expand into curved fronds.

I began the painting with a wash of a pale creamy colour all over the paper. I added vertical and horizontal bands of dilute green and blue with a flat brush, leaving rectangles of the base colour

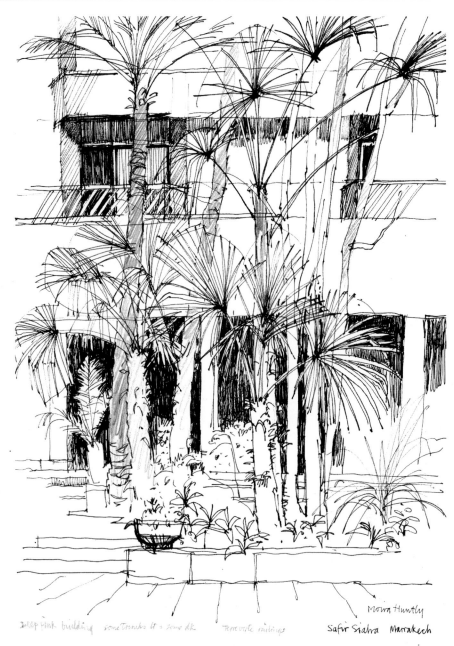

Hotel Safir Siaha, Marrakesh

350 × 255 mm (14 × 10 in)

uncovered to indicate the light parts of the building and the palm-tree trunks. I then developed the painting by putting in some darker tones over parts of the building, windows and doors, and, finally, added a few details.

Hotel Safir Siaha, Marrakesh

505 × 380 mm (20 × 15 in)

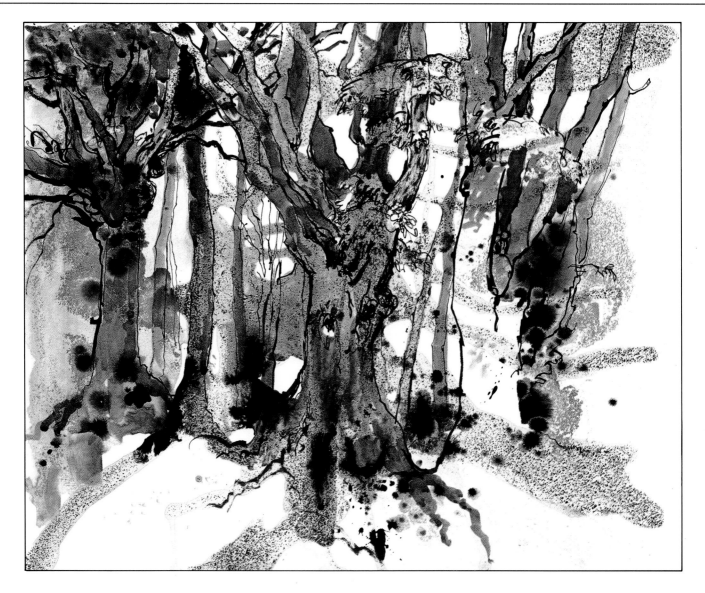

TREES ABOVE WILLERSEY HILL, COTSWOLDS

Tree forms are fascinating, and the gnarled, textured trunks of these old beech trees near my home are in complete contrast to the more exotic palm trees of Marrakesh. I made this drawing on smooth, hot-pressed watercolour paper using a dip pen and a brush with black Indian ink. I experimented with washes of dilute ink, and dropped some ink on to wet paper. The ink precipitated and created mottled textures, blots and grey-speckled areas in a very random manner.

TREE FORMS, LLANBERIS

I painted this picture in the studio from a pencil sketch that I had made in the Llanberis Pass in Snowdonia. This is wild, rugged, mountainous country full of lonely beauty and – in winter especially – the wind sweeps down the valley, bending and twisting the trees as they cling to the water's edge. The branches form an intricate tangled mass, and with angular movements they seem to reach out and grapple with neighbouring branches.

There was an ancient atmosphere here, and the dramatic effects of the

Trees above Willersey Hill, Cotswolds

300 × 350 mm (12 × 14 in)

weather over time had given the trunks and branches an uneven, irregular surface texture. My painting was an attempt to record this characteristic growth, and to create this I drew the trees with a solid stick of watercolour dipped in water, which gave a coarse textured line on the paper's Not surface.

In contrast, I treated the rocks by the side of the mountain stream, seen through the trees, in a lighter

mood, with cool colours which merged with the water cascading downward. I love the sound of rushing water, bubbling and frothing downstream, with the force of the wind sometimes sending droplets of water flying upward towards the trees.

I kept the trees mainly warm in colour, streaking some of them with orange, brown and olive green, and others with incrustations of a cooler grey-green lichen. The use of these cool colours, together with the occasional blue areas of grass and branch, helped to integrate the trees with the mysterious blue rocks in the background.

NEW DIRECTIONS

After many years, I feel that I am still trying to find my way as a painter. This does not necessarily imply dissatisfaction or uncertainty, but rather the need to search for new ideas and for ways of expressing them. Painting should be continual exploration, questioning and experimentation, with moments of elation and, sometimes, of depression.

My paintings are not preconceived, and often develop in unforeseen directions. There may be happy accidents along the way, but sometimes the impetus is lost altogether and then I will make a fresh start. Watercolour in particular can be unpredictable, but it is an exciting medium and seems to have a natural affinity with the landscape that I find very rewarding.

Tree Forms, Llanberis

350 × 400 mm (13¾ × 15¾ in)

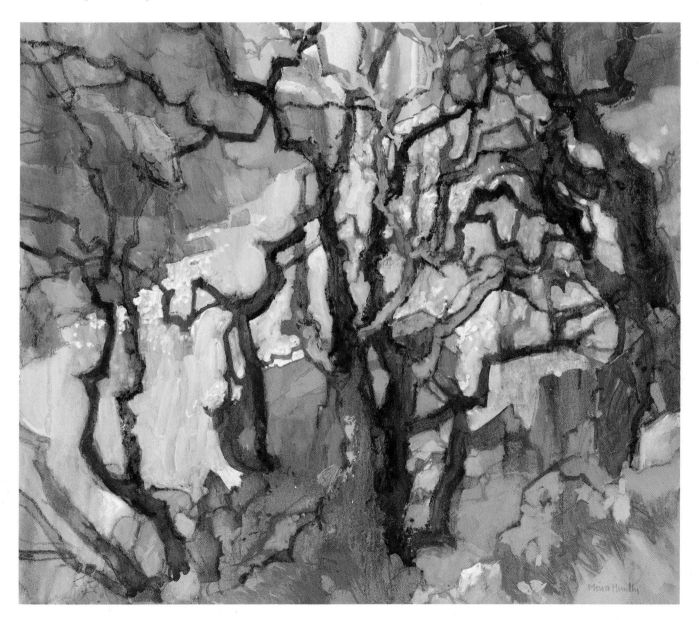

Neil Meacher

It was in the summer of my fourteenth year that I decided to become an artist and to declare this by drawing and painting in public like real artists did. Every summer many painters took holidays in my historical home town, in search of medieval quaintness. The ancient cinq port of Sandwich is still famous for its picturesque architecture and timeless atmosphere. Throughout the summer of that year, the narrow streets and riverside quays were awash with painters each seriously 'doing their own thing' for all to see – a veritable street theatre.

All through the school holidays we youngsters mounted a bicycle patrol to search the town for painterly persons. The white sunhats, navy and tan kettle-smocks with red and white spotted kerchiefs and Greek sandals were a recognizable uniform.

When an artist was discovered at work, we stationed our bicycles in a half-circle behind the painter and waited, astride the crossbar, to see the painting develop. A fascinating performance some of those artists provided, sighting at our town through small apertures cut from card and squinting to measure angles with outstretched brush or pencil, then standing with noble kidney palette at the ready and brush poised for the first dashing brushstrokes. We yobbish youngsters enjoyed all this hugely, and were loud with criticism of every mark.

Initially, it was all the paraphernalia of painting which captured my interest and the mysterious persona of the painters – their essential difference. All this sparked a positive sympathy from within myself and the first flickerings of a sense of identity. Very soon I acquired a sketching stool and sat down in public to draw with pen and ink. I was warmed by the kindly interest of many townspeople and friendships resulted from my new stance as an artist. As Raoul Dufy said, 'He who finds his vocation in youth has found his salvation. In giving us our *raison d'être* early in life Providence grants us a great favour.'

The carrying of a sketchbook established a core of purpose for my somewhat solitary teenage state. Hours spent in solitude along the tideline or in watching birdlife on the estuary could be crystallized into drawings and written notes. I could make a product from what I liked doing best. And so the pattern was early set, and forty-four years later, I still like nothing better than to go exploring with my sketchbook. I confess to being entirely nutty about making marks on paper. I have become a compulsive draughtsman.

North Cornwall Dream Haven

375 × 540 mm (15 × 22 in)

ART SCHOOL AND
EARLY INFLUENCES

I entered full-time art and design education in 1951, during an era when drawing was taught as the paramount skill. At Canterbury College of Art, emphasis was very much on the English tradition of linear drawing – fostered by the influence of John Ward, who was a visiting celebrity. I was fortunate to attend during the despotic reign as principal of John Moody, who kept both staff and students hard at work. No three-hour lunch breaks in local pubs for any of us. In this demanding atmosphere of dedicated application, there were few examination failures. Even the 'horsey' county girls finished the course with a diploma rosette.

In those days, students were entitled to four years of art and design training. The first two years were concerned with learning how to draw and how to employ tone and colour. We were taught perspective and human anatomy and educated to appreciate architecture and product design, from ancient civilizations to modern 'festival times'. Each of us was required to choose a craft subject for special study during the following two diploma years. I divided my craft activity between textile design and print (silk-screen printing) and sculpture (modelling in clay and carving in wood and stone). These areas of study taught me to formalize two-dimensional pattern from nature and to assess three-dimensional shapes as sculptural forms.

Throughout my time at Canterbury I aimed at becoming an art teacher and not a self-determining artist: a very safe and sensible decision which was much applauded by my middle-class parents. I could have achieved this with just one more year of study at any major college offering the art teacher's diploma qualification. However, I was strongly influenced to apply for entry to the Royal College of Art and so to arrive at a rather more illustrious qualification, which would lead into art college teaching and provide three more years of personal creative development in London. This is the route I chose.

The preliminary years at Canterbury established my basic art skills and provided five elemental values which are now always evident in my work – a love of line and linear design, a certain drawing skill, the ability to derive pattern and texture from any subject, a feeling for the sculptural strength of shapes, and finally the capacity to control these elements within the overall design of my pictures. In fact today everything I draw is redesigned from the original subject (more of this later).

Much of this basic ability I owe to the dedicated teaching of Eric Hurren and Christopher Alexander, who worked hard with the Intermediate students (first two years) at Canterbury to inculcate sound thinking and an enthusiasm for drawing. Both lecturers were devoted to sketchbook activity – not only because these intimate records had to be submitted for the Intermediate examination, but also because they were totally committed to personal research through drawing. Chris Alexander was never without his sketchbooks. He carried them everywhere like a shield of

Designs for textile prints

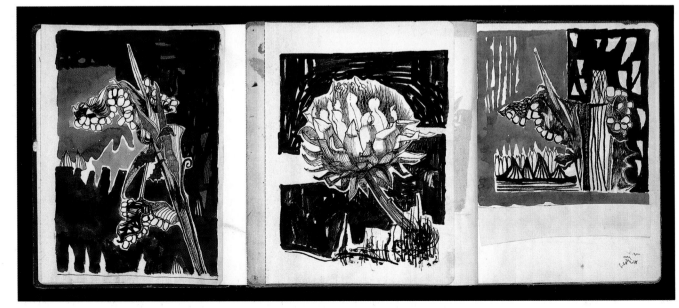

faith and we considered it a great privilege to look through the pages of drawings or to be invited to go drawing with him. It was he who introduced a small group of us diploma students to the magical world of London private galleries in Bond Street and Cork Street. In these plush and awesome places we spoke in reverential whispers as we communed directly with pictures and sculpture by our personal heroes.

INFLUENCES AND HEROES

The main focus at Canterbury was on achieving excellence in working techniques (an influence surviving from the faded Arts and Crafts Movement). It was not until I studied at the Royal College of Art that I began to perceive that more was required in a picture than technical accomplishment. However, at Canterbury I had been introduced to the work of those English artists who became my personal heroes. These were chiefly the War Artists (1939–45) and those who were classified as the British Neo-Romantic School. In particular Graham Sutherland, John Piper and the second-generation neo-romantic John Minton were most influential. Sutherland's influence can be seen in my student designs for textile prints, and Minton's in the location drawings I made at the same period. As an adolescent youth from the countryside of Kent, this English romanticism with its roots in Samuel Palmer and Edward Calvert greatly appealed to me. I launched headlong into the poetry of these artists and took every opportunity of scrounging visits to London and searching out their pictures at the Leicester Gallery and in Cork Street. It was on these visits that I also discovered the beautifully designed and sea-washed pictures of artists from the St Ives school of English art – the sparse classical beauty of pictures by Ben Nicholson and the lovely linear warmth of paintings by Patrick Heron, with their echoes of Braque.

At about this time I happened to be in Scarborough on holiday and was attracted to an exhibition of paintings displayed in what had once been a large private house and was now the municipal gallery, I think. I wandered through sunlit rooms hung with dozens of large paintings by Patrick Heron. The free-flowing linear drawing in paint and the infill of shapes with delicious colour touched my own sensibilities deeply. I can still remember many of the pictures in some detail, although at the time I had no clear understanding of the reasons why an artist might work in this way or of the cubist influence evident in his images. My heart still misses a beat when I come across Patrick Heron drawings of this period, and I can see his influence increasingly in my own drawings.

This London cocktail of visual awakening was an intoxicating mix for a provincial lad, and back on the seashores and marshlands of home I tried to shape my own vision within these English parameters. From the outset I felt myself to be part of the English tradition. I still feel this way today, although the mix is now spiced with a profound appreciation for Picasso's achievements and lightened by the *joie de vivre* of Dufy's images.

Location drawings, England, Italy, Holland

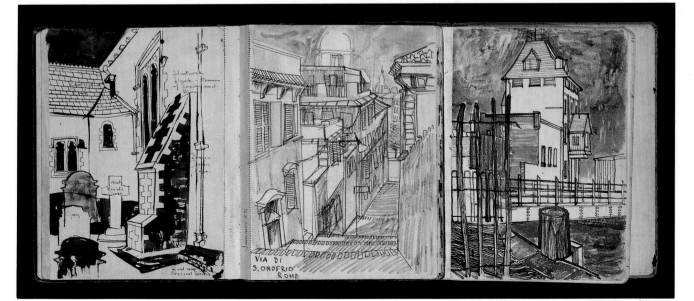

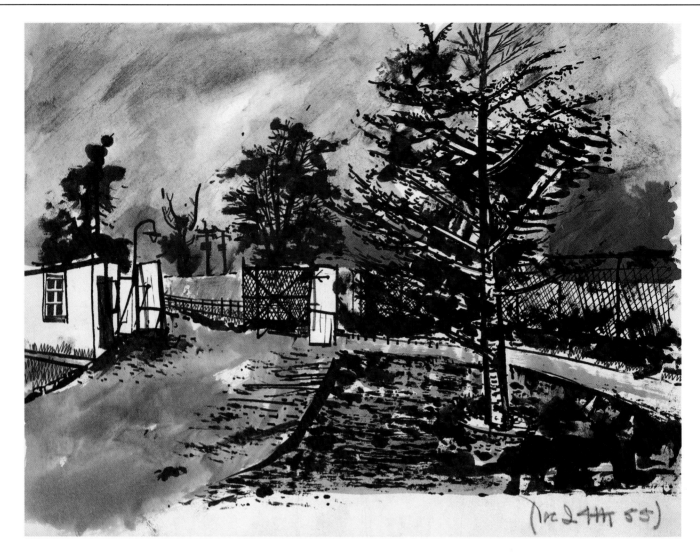

NATIONAL SERVICE

I survived two years of khaki confinement in the Royal Army Education Corps – largely because I always carried a talisman sketchbook in my battledress tunic pocket, over my heart. When conditions became intolerable, I was able to distract myself from reality by drawing whatever was happening, as in this ink drawing of 1955. Again, it was the awareness of myself as an artist, rather than as an army school teacher which kept me buoyant. Nothing of any artistic significance happened during this military service. I drew whenever I could and lived for the rare days of leave when I could visit London galleries as I

passed through the capital on my way to east Kent. I kept my sanity by focusing forward to the coming years in South Kensington and the Royal College of Art.

THE ROYAL COLLEGE OF ART

After the initial thrill of my transformation from khaki-drab into full-colour freedom, I began to realize that I was wrongly cast as a textile designer and I was allowed to transfer to the School of Engraving, where I could once again think in picture-making terms and exploit my drawing skills through the medium of etching and lithography.

It took me many months to

The Guard Hut, Christmas Eve
190 × 255 mm (7½ × 10 in)

become accustomed to the tradition that little formal teaching was forthcoming from the illustrious members of staff. These famous artists were pushing firmly along their own career paths and production of their own work was uppermost in their vision. In those days there existed an almost feudal divide between staff and students and we had to summon up real courage to gain any personal attention. Self interest was everyone's entire concern – the personal push for fame. David

Hockney was just a mate, waiting to use the etching press when I had finished with it. We students learned mostly from the technical assistants, when they had time left over from servicing the lecturers. Most of us worked away from the college in the bedsitter lands of South Kensington and Earls Court, in order to preserve in private our tender creative sensibilities. In those rooftop and basement rooms we had important lessons to learn about life – with girls more exotic than the female blooms of marshland Kent.

My period at the RCA was far from comfortable. Growing and developing artistically is a painful experience (and it still is because 'Art is a high risk business' – John Plumb). Looking back through a filter of experience I can see that I was too inexperienced and shy to take sensible advantage of any opportunities which the place offered. I think that I gained most from simply 'being there'. It gave me a sense of measure and membership of a select club, which was certainly of value when I applied for teaching situations in colleges of art during the sixties. However, what I now know and practise as an artist I have largely taught myself since 1975, when I was forced to accept that my teaching work in higher education had no long-term future because of government cuts to art and design training.

What Is There Left to Dream about?

560 × 380 mm (22 × 15 in)

A SKETCHBOOK LIFE

The purpose of this volume is to go beyond what is offered in standard how-to-do-it books and to present for the serious amateur artist an insight into the way that professional artists think, work and acquire a personal vision. For this reason, I have revealed the early stages of my

training, to provide an insight for those who have not had this advantage. I also wish to make it clear that learning to become an artist requires just as much application and hard work as training for any other profession. A person may be born with a temperamental aptitude for making marks and a certain manual dexterity, but these abilities have to be developed through consistent

hard work and be married with trained thinking before anything resembling 'art' can be born. From the outset competition is fierce, and because many factors are somewhat intangible there are times when you

lose your secure footing and anxieties set in. An artist can never settle into a comfortable mode – there must be an ongoing process of assessment so that you can learn to recognize your own limitations and acquire the courage to work within them.

It is also important for the serious amateur artist to realize that 'art' is the creation of the mind. It is a vital, living activity which pushes its frontiers forward every day. Those artists who are at the cutting edge are taking high risks. This is why it takes a strong personality to remain there – and also why most of us, more gentle souls, are many miles behind the frontier in safer places and on tested ground where we build stockades from more acceptable ideas and live a quieter life inside them.

As previously mentioned, I have constructed a stockade from a personal mix of very English artists, to which I have added the zest of France through the work of Picasso and Dufy. Those who have influenced my own development are always 'designer artists' with a strong linear element in their work. The English linear tradition has grown from illuminated manuscripts rendered with graphic mediums rather than plastic ones. In this sense I am also a graphic artist, producing pictures in my preferred medium of ink line and watercolour. The majority of my pictures are relatively small in size and precisely worked, never far from book scale.

I work most often in sketchbooks, because they accompany me daily and are always waiting to receive drawings and notes, whenever I have an opportunity to concentrate. In fact my sketchbooks have now become journals and the drawings combined with words are probably the best things which I create, in the sense, as Keith Vaughan says, that 'art is abstracted from life and not art'. Eugène Delacroix, writing in his own journal, declares, 'It is often that we come closest to the essence of an artist . . . in his or her pocket notebooks and travel sketchbooks . . . where written comments and personal notes provide an intimate insight into the magical mind of a working artist.' Delacroix also had a passion for notes and sketches and made them wherever he was. He was fully aware of the appeal and intrinsic value of sketches and noted in his journal, 'a fine suggestion, a sketch with great feeling can be as expressive as the most finished product'. Elsewhere, he wrote, 'Perhaps the sketch of a work is pleasing because everyone can finish it as he chooses. To finish requires a heart of steel – one must make decisions about everything.'

THE DAILY SKETCHBOOK

Like writers and poets, artists must always have pencil and paper to hand because pictorial ideas can so easily slip away if not promptly recorded. This is especially true for artists who work from their imagination. The only tangible form that can be given to pictorial visions is to draw them while they remain vivid. These days I always carry everywhere a mini drawing kit and sketchbook, both of pocket size (see below).

A soft plastic pouch designed for carrying spectacles will accommodate a useful selection of drawing tools and fits snugly into the pocket

Mini drawing kit

or a personal bag, along with a slim A6 sketchbook. You can see from the photograph which tools I carry. This is a very personal choice and each artist would make a different selection. Any decision results from considerable trial and error. With my choice, I can work anywhere for a week without needing more materials.

With experience comes the desire to simplify and the knowledge that an abundance of art materials in a bulging sketching bag does not make the real issues of seeing and drawing any the easier. You only really need pencil and paper. This belief is always reinforced when I draw on location with Raymond Spurrier, because he uses the simplest means of recording information, a basic cartridge-paper sketching block and pencil. At the end of a working day he has produced half a dozen A3 sheets of lovely free linear drawings which display the unmistakable lyricism of his very personal pictorial handwriting. It is not tricky techniques which give an artist stature at this level of information gathering, but sound drawing ability and a simple, direct approach.

SNAPSHOT DRAWING

Whenever I arrive in an unknown location, my first task is to assess what the environment has to offer in terms of picture-making ingredients. Experience reminds me not to rush out, full of enthusiasm and launch myself immediately into renderings of the picturesque, but, rather, to invest a day or two in gradually coming to an understanding of the new place.

Over the years I have invented a simple analytical drawing technique which helps the process of visual assessment. For want of a better title

I call it 'snapshot drawing'. This method of working involves using a small card viewfinder with an aperture the size of a matchbox, to aid the selection of subjects. Most people will have used a viewfinder at some time, and will be familiar with the technique of squinting through the aperture to assess the pictorial possibilities of a chosen subject. Having decided on a particular view, I then place the viewfinder on the sketchbook page and draw within the aperture, which now frames the sketch. The smallness of the aperture forces me to draw using a brief, linear shorthand and this further aids the simplification process. In addition, I limit myself to twenty minutes for each drawing so that I can concentrate the mind on the essential elements only. I am always looking firstly for the big, basic shapes of a subject and then at how these are subdivided into smaller shapes, which can be exploited as pattern and texture to enrich the drawing. Reducing any subject to line transforms it into an image of classical cleanliness. For example, in the 'snapshot drawings' of Port Isaac (overleaf) you will note how I have made each composition from a simple linear outline of the buildings and then concentrated on the secondary patterns of stonework and tiles, so as to record important regional characteristics of vernacular architecture as well as decorative pictorial elements. These little

drawings also record light because shadows confer solidity to linear drawing and create more compositional shapes. Colour can be conveyed in simplified monochromatic terms by using various weights of tone. These, in turn, contribute more pattern, like dark stones in a lighter wall.

So with all this in mind, I go forth carrying just a sketchbook, viewfinder and a mechanical pencil (these pencils provide a constantly fine line). I explore the new location, stopping wherever a subject demands my attention to produce a twenty-minute drawing, then moving on once more to cover the whole area, very much in the same way as a photographer uses a camera.

I have introduced holiday course students to this method of surveying the terrain for pictorial information, with very encouraging results. Once students have practised this simple drawing technique, they are well equipped for sketchbook activity. They are always delighted to discover that 'information-gathering' can be this simple and that it does not require them to render fussy mini-versions of finished pictures. A similar shorthand drawing language is developed by all experienced artists and it is the essence of the 'working process'. Such shorthand rendering from reality produces what professional artists call 'signs'. These are carefully edited versions of

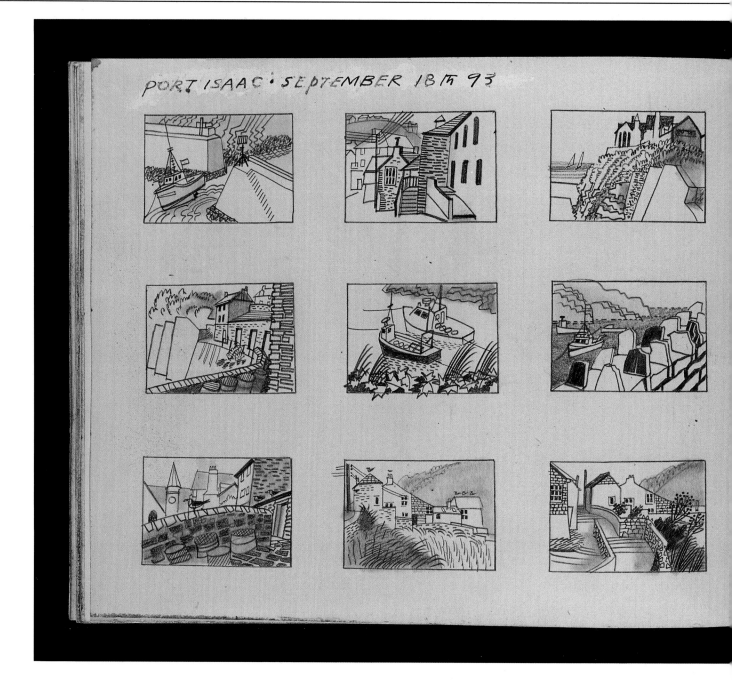

'Snapshot drawings', Port Isaac

203 × 505 mm (8 × 20 in)

reality, in which non-essential elements are removed in order to create graphic simplicity. This very special skill is evident in every drawing and painting by the French artist Raoul Dufy, who perfected the vision of simplifying all subjects into a deliciously elegant calligraphy of graphic marks. The 'snapshot drawing' method starts students thinking and working in this direction.

WORKING TOWARDS SIMPLICITY

Gradually I have learned to respect artists like Dufy who have had the courage to present a simplified sign language in their pictures. This way of seeing strikes a nerve in my own psyche. From earliest student years I was never entirely happy to produce the meticulously detailed renderings that were then required of us. I

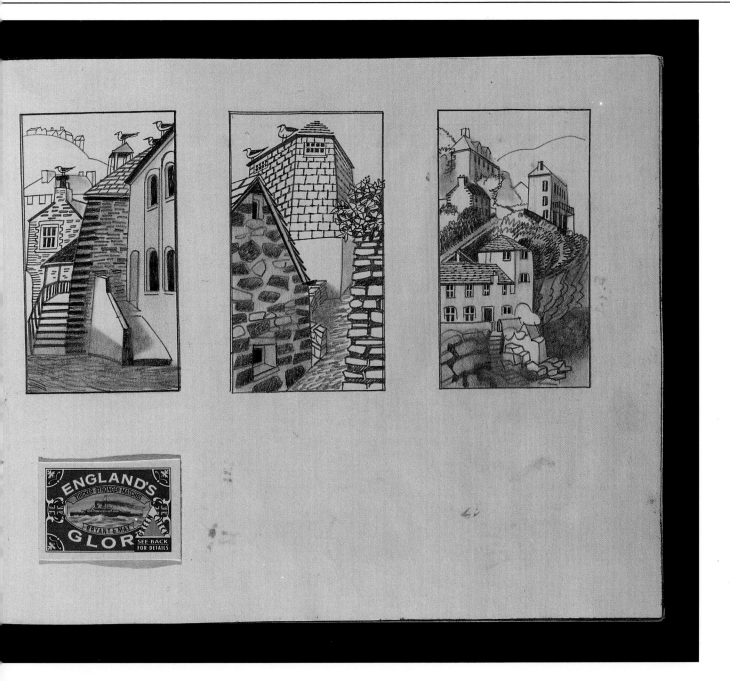

always had too much respect for photography and cinema film to believe that artists should be striving for a similar realism. Over the years I have come to appreciate that it requires much experience to draw selectively, to comprehend and render only the essentials of a subject and so represent it as a 'sign'. By performing this task, the artist is providing viewers with a clarity of insight which can promote an entirely fresh understanding.

Selectivity and simplicity of rendering are increasingly my artistic aim. Towards this end, I search for subjects which are in themselves simple and which can be converted into 'signs' that allow endless composing and rearrangement, in exactly the way that Ben Nicholson used traditional still-life objects like humble household mugs and jugs as a basic motif and then exploited their simple shapes into endlessly changing compositions. Picasso capitalized on the human figure in the same way. My subject matter is increasingly the shoreline and harbours, with all the paraphernalia of boats. I grew in up close association with the sea, on the marshlands of south east Kent, where I sailed my own gaff-rigged dinghy on tidal estuaries and muddy creeks. When, in 1975, I started to

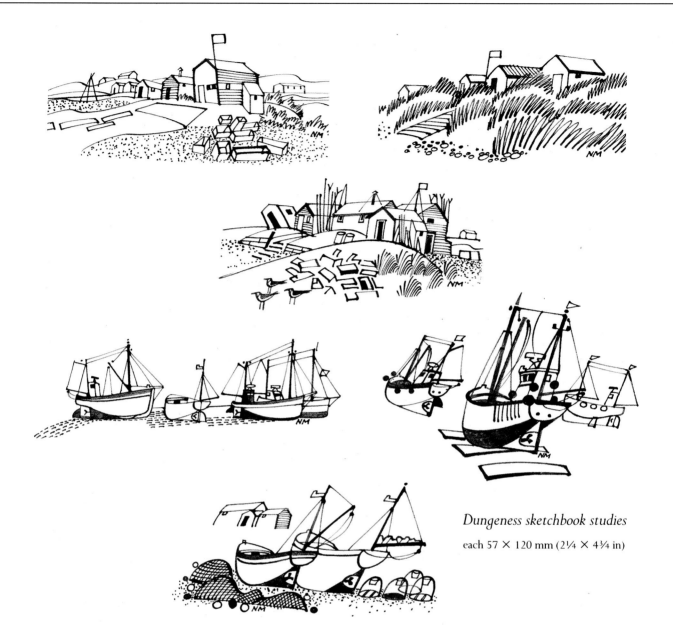

Dungeness sketchbook studies

each 57 × 120 mm (2¼ × 4¾ in)

build a personal life as a creative artist (as opposed to focusing entirely on teaching) I found my interest swinging back to the magnetic Channel coastline for inspiration.

A Childhood Landscape

In particular I am motivated by a continuing love affair with Romney Marsh and especially the shingle landscape of Dungeness. I am very moved by the bleak austerity of the place and the elemental simplicity of the landscape. The terrain is a vast spread of shingle dotted with black-tarred huts, houses and families of fishing boats. Everything man-made is entirely functional – it is only there if it is useful or has once been so. All these objects are set out on the flat shingle like a continuous still-life of simple cubist shapes. So fundamental are these objects that I can rearrange them on paper time and time again.

The whole area is full of a poetic power which has previously attracted many artists of reputation, for example, John Piper, Paul Nash and Eric Ravilious. Today the region still offers inspiration to contemporary artists. Graham Clarke has exploited the quaintness of resident fisherfolk and their timber homes in his famous arched-

(Facing page) *Four location sketchbooks*

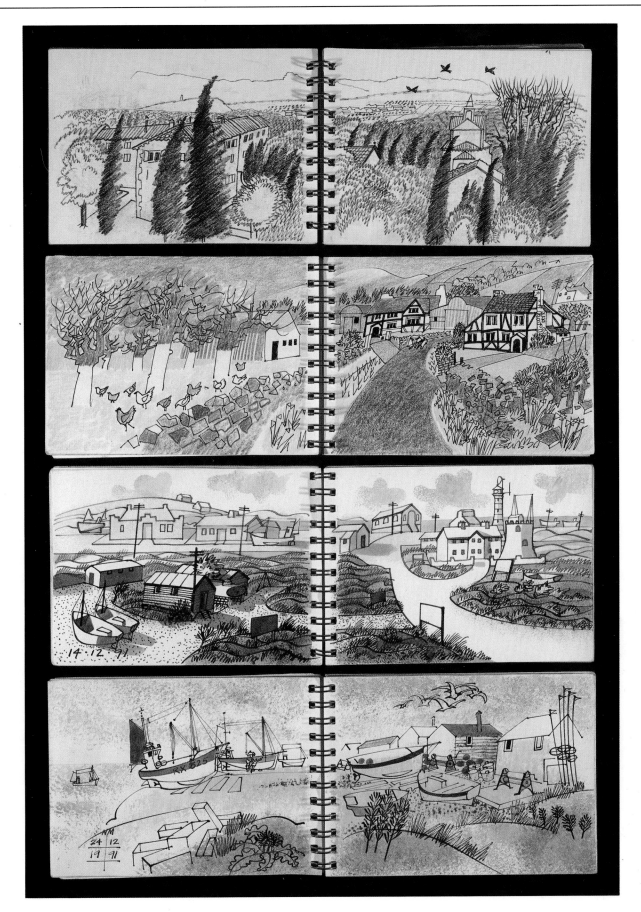

top etchings. Brian Yale owns a traditional timber longhouse within sight of the shore and spends much time painting, in potent realism, the somewhat surreal combinations of objects which litter the shingle. Whenever I draw at Dungeness, I can feel the pervasive influence of earlier English artists and because I know their thinking and their pictures so well, I feel part of a tradition which they established.

SKETCHBOOK MEDIUMS

Most of the small pen-and-ink drawings on these pages are taken from Dungeness sketchbooks of A6 size. These are small spiral-bound pads of basic cartridge paper, which open flat for landscape subjects across the double spread. They are humble little books and not robust enough for prolonged use on location, but are a very useful pocket size. The way in which I work can be seen in the four location sketchbooks. It is based on traditional methods established by artists like Francis Towne and John Sell Cotman, who began by making a line drawing and then laid colour into it, the line often remaining dominant and holding the picture together. This is the method that I teach to students on holiday courses, and I present the stages of working here so that you can gain a clear understanding of this lovely technique.

Marine Subjects shows nine pages measuring 127 × 175 mm (5 × 7 in) of ink line drawings, which have resulted from various drawing expeditions. You will note that they are very simplified drawings which concentrate entirely on shape and pattern, because this is the essence of picture-making. Finer detail and textural enrichment will be provided by the watercolour.

From this group of nine line drawings, I have chosen four in Sketchbook Studies and taken them progressively to a finished state, so that the stages of working are clearly evident. Stage one is the basic line

Marine subjects

each 127 × 175 mm (5 × 7 in)

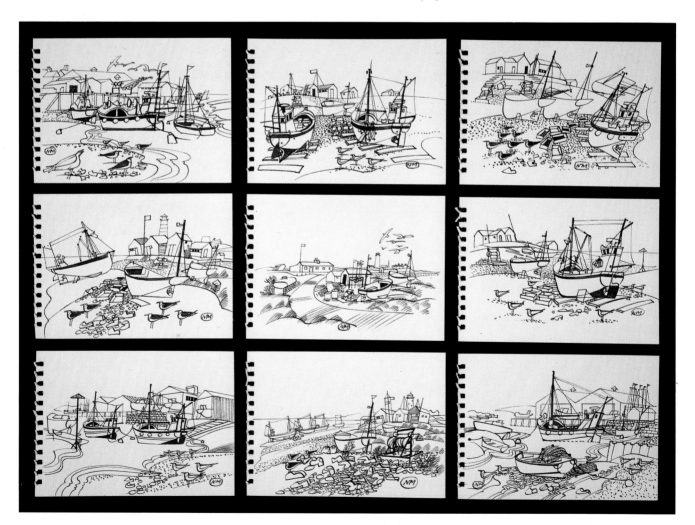

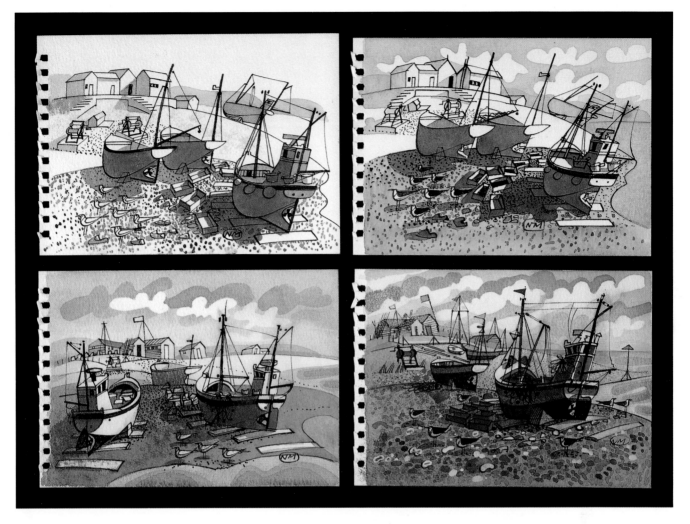

Sketchbook studies

each 127 × 175 mm (5 × 7 in)

drawing which is the foundation design of the picture. In this drawing values like perspective and variations in scale must be convincing, because changes cannot be made at later stages. The second stage involves an accurate observation of shadows and the rendering of these in watercolour wash. I have used three strengths of tonal shadow wash, to create a sense of aerial perspective by clearly defining foreground, middleground and distance. Sepia and a neutral tint like Payne's grey are traditional wash colours for this medium. It is always exciting to see how the somewhat flat line drawing becomes positively three-dimensional when accurate shadow is laid upon the shapes. Traditional line-and-wash drawing

went no further than these two stages, with the shadow washes being made from the drawing ink. This is exactly how Rembrandt worked. Later artists invested the technique with further enrichments of their own.

In stage three I am beginning to establish areas of colour which also add to the drawing of shape, as with the sky. The joy of watercolour washes is their transparency. They act as a colour glaze which lets the shadow areas show through. The over-painted shadows take on a 'tint' of the colour wash and thus become a mix of the two. This method of using watercolour is called glazing. It involves building up the strength of colour stage by stage, and although this takes longer than more

direct painting, it does enable an artist to assess progress gradually. Glazing is particularly appropriate when building colour within a line drawing or when a rich luminosity of colour is required. All my gallery pictures are produced by this glazing method.

Stage four shows how the sky is further developed and more colour added to the beachscape. Secondary aspects of the composition, like the fishermen's huts, can also be given colour. It is now a question of working carefully over all the shapes in the drawing to establish each of them in colour.

The last stage is quite an anxious one for me, because it demands careful judgement about how much detail and enrichment to add. My biggest concern is to retain a simple freshness of treatment, and sometimes this involves recovering the sparkle by painting light into darker areas. This can be done by adding a touch of white gouache to the watercolour mix. Note the light yellow stones on the foreground shingle.

Preliminary working

THE WORKING PROCESS

All this sketchbook activity is a vital part of an artist's 'working process', which can be described as all aspects of the preliminary work from which finished pictures result. Students of art and design are increasingly interested in this process as a means of understanding what the artist is trying to say to the world. Some artists now prefer to offer their 'working processes' as their entire contribution, believing that creativity can be just as evident in words and sketches as in grander works.

It is during this preliminary period that all the hard work of idea evaluation and picture planning is done and the concepts and composition worked out. This is what students are now taught during an art college training, rather than techniques of producing artwork. Serious amateur artists have little awareness of the need for this preliminary activity or indeed what it involves. They fail to realize that the authority which they recognize in professional work results chiefly from the long hours spent sorting out pictorial problems on paper before any work is begun on a finished rendering.

Because of the importance of all this preliminary processing of ideas in sketchbooks and because the

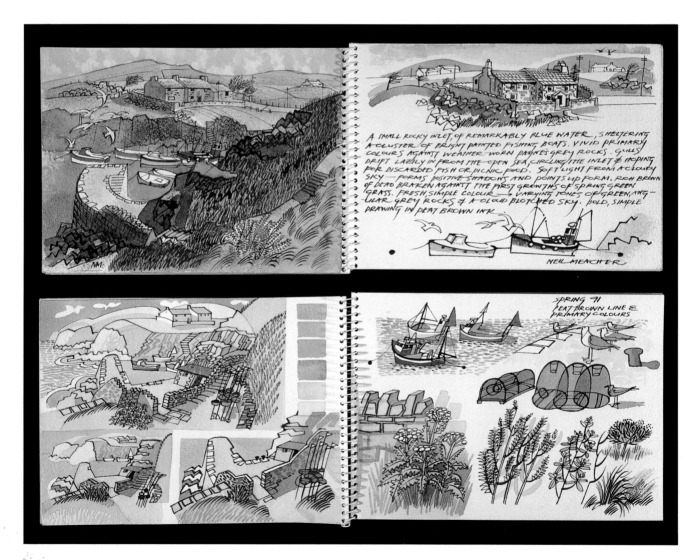

No subject or scene falls naturally and truthfully into an ideal arrangement. The artist, however, has this advantage over the photographer – that he can move elements about according to the laws of perfect composition. Creativity exists in the redesigning, not in a factual rendering. For me reality is the starting point from which to develop something of my own. I have always found it somehow lacking the full dimension of possibilities. The world is too full of realities, which television brings daily into our consciousness. Mine is an escapist vision and I have always set up my easel on the sunny side of truth. Thus I translate from the real into a heightened idyll of classical charm, where sunlight floods the composition and warms the senses. I always make happy pictures. These two sketchbooks show the beginning of the process

amateur artist has little experience of this vital preparation, I have chosen to make my contribution to this book largely from my sketchbooks and journals. As I have already shown, the various techniques and attitudes of sketchbook working are an essential aspect of the working process. However, much processing also goes on inside the artist's head and for most professionals this never stops. No matter what we are doing, some portion of the mind is busily at work assessing all the visual information which is arriving through the eyes.

PRELIMINARY WORKING

Of the two sketchbooks shown here as examples of preliminary working, the top one reveals the working drawings and written notes I made on location, in front of the subject. The second book shows part of the

planning and redesigning work which I continued back in the hotel. You will note that I have made simple colour drawings which provide truthful information about the design of local fishing boats, types of lobster and crab pots, style of stone walling and resident plants. All this adds secondary detail, but the important task is to reassemble the major elements of this coastal inlet into a more telling composition.

and *Gull Haven* (overleaf) presents the created idyll. Of course, the process never quite captures the dream and so this particular composition can be reworked again and again (and will be).

Finally, I want to present four illustrations from a recent sketchbook journal, which I have chosen because they encapsulate most of the concepts that I am trying to communicate. All four double-

page spreads are taken from my summer '93 sketchbook and result from a working visit to Roscoff in Brittany. I chose the location carefully because Brittany contains an abundance of the subjects from which my idylls can grow. So excited was I by the coastline and marine influences of this enchanting limb of France that I drew day and night, hardly pausing for the delicious *fruits de mer*. Fortunately my wife also has an art school background and thoroughly understands that creativity is a hard taskmaster.

Rocky Peninsula, Roscoff (page 98) shows a linear drawing in waterproof sepia ink, drawn with a traditional dip-pen and steel nib and with shadows cast in a mauve (complementary to the sepia) watercolour wash. My concern was to record the massive shapes of rounded rocks which form much of the coastal terrain and the way in which domestic and commercial architecture is fitted between these huge boulders. The sharp angularity of the buildings contrasts excitingly with the enormous weather-worn natural forms and all are softened by feathery pine trees, which grow almost to the water's edge. This small harbour has been fitted into the landscape and not imposed upon it. The view is seen at high tide, with calm glittering water stretching away to countless offshore islands and marker lights spaced in every direction. At first sight, I knew that this was the raw material for many future drawings (whenever I can allocate the studio time).

Gull Haven, Pembrokeshire, Remembered

380 × 560 mm (15 × 22 in)

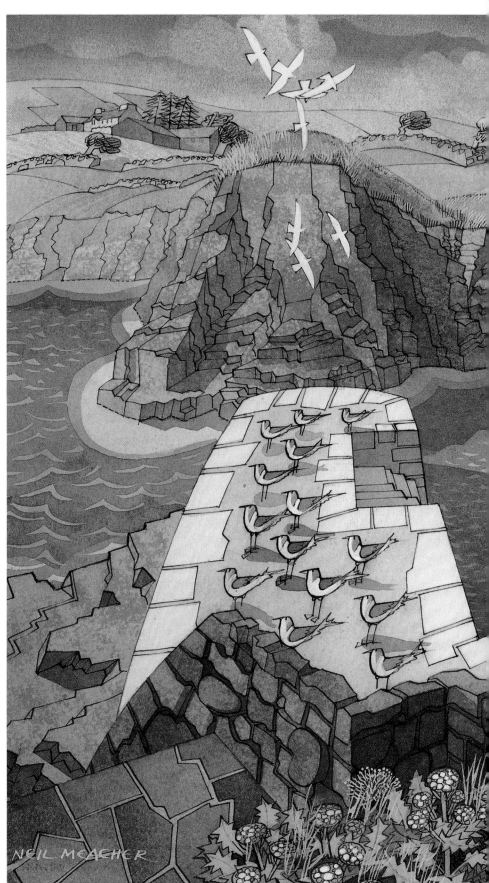

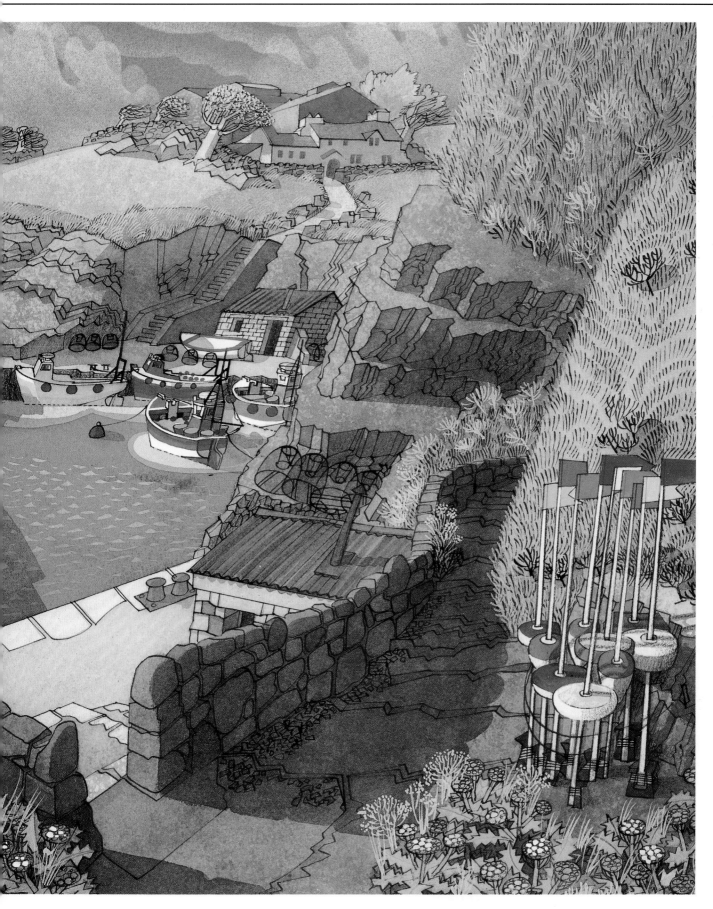

(Above) *Rocky Peninsula, Roscoff*

203 × 505 mm (8 × 20 in)

(Below) *Low Tide at Roscoff*

203 × 505 mm (8 × 20 in)

Time is especially vital when working on location, and it is imperative to take advantage of all visual material which comes to hand. Any French resort has large numbers of postcards – probably the most beautiful in the world, since local photographers produce images from a deep love of their native place. The photographic fragments pasted onto these pages came from give-away brochures available at our hotel and the tourist information office. The images are all aspects of the region which cannot necessarily be visited during a brief stay, but which are vital ingredients of the idyll. The point which I am trying to make is that so much visual information is available if one is alert to the possibilities, and the sketchbook is the sensible place to store it.

Low Tide at Roscoff is a straightforward double-page drawing in pen and ink, again showing the amazing formation of rocks which form the coast and also exist below the tideline. Low tide reveals a seabed like a sculpture park, with the

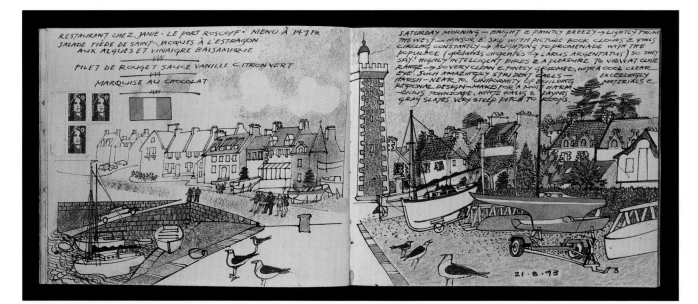

(Above) *Harbour Promenade, Roscoff*

203 × 505 mm (8 × 20 in)

(Below) *Harbour Subjects, Roscoff*

203 × 505 mm (8 × 20 in)

sea as a distant frame, and fragile boats in colourful abundance. Along the horizon lies the delightful Ile de Batz with its rows of clean white cubist houses. My sepia ink was almost exactly the colour of the coarse regional granite and by applying the ink and watercolour with a sponge, I could reproduce the exciting gritty texture characteristic of the whole terrain. Drawings like this measuring 203 × 505 mm (8 × 20 in) overall take about three hours to complete – which means in reality a whole morning devoted to

one image. However, this is a worthwhile allocation of time where the subject will lead directly to a gallery picture.

The double spread of the harbour and promenade demonstrates another aspect of sketchbook value and of the working process – the sketchbook as journal and diary. Increasingly I am interested to gather written information about those areas of daily experience which cannot be rendered into visuals. For example, the lunchtime menu which must never be

forgotten and addresses of charming table companions. All manner of fascinating details of place and events can add a further dimension and a warm reminder of rewarding experiences. For many people this is an entirely new concept of how a sketchbook can be used. Some have found it to be a delightfully liberating discovery, enabling them to contain in one form all the impressions that travelling offers. It is so convenient to have everything available for reference in book form.

Harbour Subjects, Roscoff (page 99) illustrates further the fun of keeping all the printed ephemera with a whisper of national character, and, indeed, useful information for return visits – better hotels with more scenic views, notable restaurants, or whatever you personally find significant. Sketchbooks should reflect a very personal world. They can become a vehicle for self discovery and a positive lifeline for those of a solitary disposition. Their therapeutic value is immense.

I have tried to reveal clearly those aspects of functioning as an artist which go beyond the craft skills. This book is conceived as something much more than a 'how-to-do-it' programme. Those who agreed to participate in the writing of it accepted the challenge of revealing sensitive areas of their own thoughts and feelings with the aim of presenting the realities of a life committed to art. For each of us it is a sentence of solitary confinement which is displayed for public enjoyment and some financial return (anyway that is how I see it!).

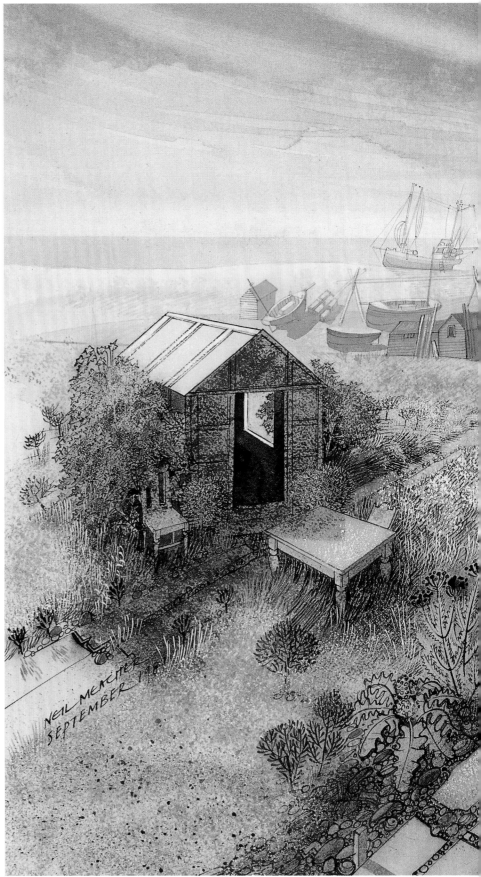

Dungeness Morning

380 × 560 mm (15 × 22 in)

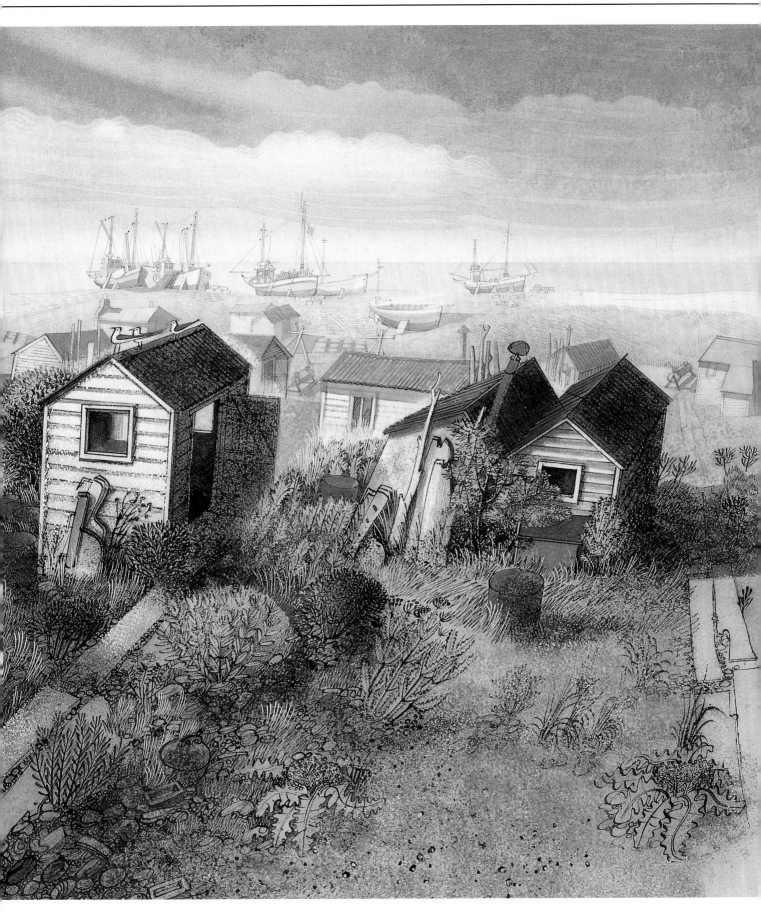

Raymond Spurrier

Painting is a practical craft which, in days gone by, demanded years of dedicated apprenticeship in the workshops of the masters. Today, in many a book and video, it is made to look easy, and in a sense it *is* easy. The rudiments of watercolour painting can be described and demonstrated in a short afternoon, while constant practice may lead to some fluency with the brush – yet there is more to it than that.

As painting is also a creative process, attitude of mind is at least as important as manual dexterity. What distinguishes artists from other people is not so much their ability to lay a smooth wash or paint fabulous stormy skies wet-in-wet, or even to draw accurately in perspective (good pictures have been made without any of these things), but their constant curiosity about the visible world and the skill to select from it subjects for paintings. What matters most is a probing and perceptive eye, and the temperament to be excited by what is seen.

SEEING THE SUBJECT

Before you can paint a landscape – or anything else for that matter – you have to be able to *see* it, and in a special kind of way. An assembly of interesting landscape features such as an old barn, a bunch of trees, a distant hill, a twisting lane and so forth, may seem like a promising subject. But, before it can be turned into art, such a group must be perceived as an abstract arrangement of shapes, colours and tonal values that can be translated into patches of paint. In other words, you must see it as a set of relationships. The contents of the view are not that important, but what comes next to what *is* important, because features well separated in three-dimensional space may become pictorially adjacent on the flat picture plane.

And so I potter about, always hoping to come across an exciting set of relationships or a collection of shapes and colours that, by being pushed around a little, can be made exciting. I suppose what I am really looking for is something of the poetry of landscape – not an easy thing to pin down in words, let alone in the visual language with which painters must work.

I am not qualified to explain the elusive nature of creativity, but I do believe it possible to adopt working methods which may at least put one in touch with the creative muse. For those brought up on the step-by-step routine, which assumes that painting is like baking a cake, some of my procedures may seem casual; but they are all geared to the chance of making something interesting happen on the paper.

The great thing about painting and drawing is its unpredictability, and that delicious element of risk which can often lead to expressive results. So I work away intuitively towards what feels right, letting one mark lead to another, although never quite knowing how it will turn out, and being pleasantly surprised if the result is at all exciting. In this way it becomes an adventure which may lead to something wonderful – or, of course, it may not, but that is the risk we take. Most painters throw away more than they frame. Either way, the resulting image is far more important than any subject which may have inspired it, because art is more than just copying appearances.

Marennes

435 × 320 mm (17¼ × 12¾ in)

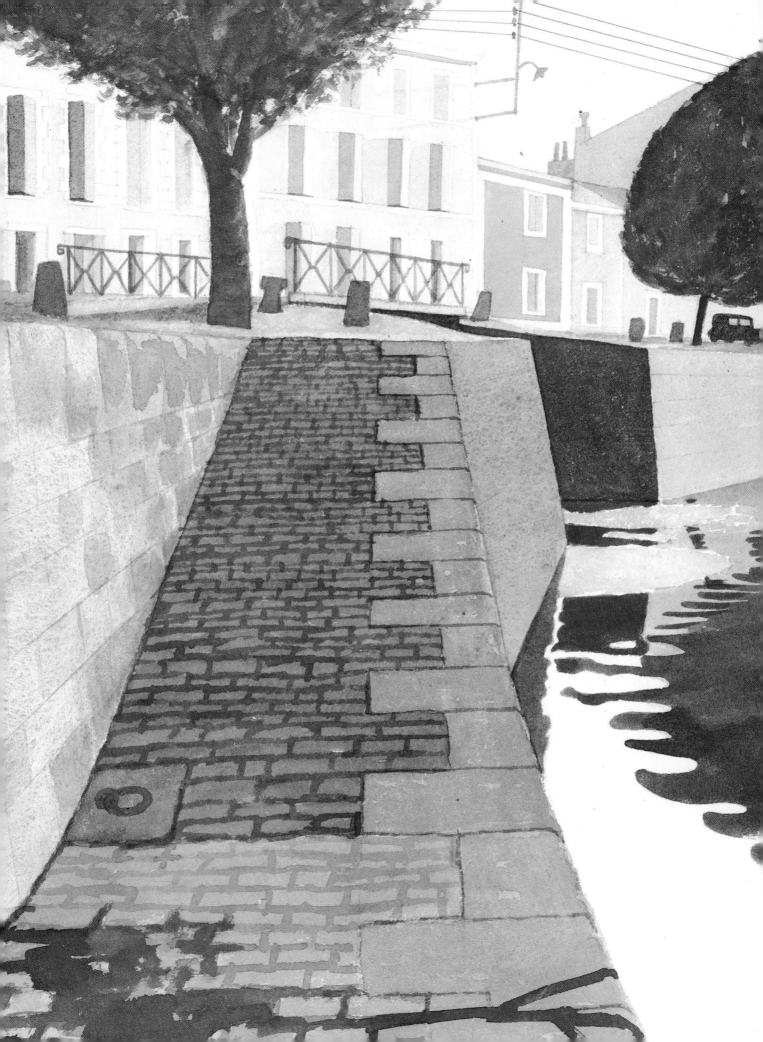

I do need a subject to start me off – a slice of reality and preferably something which, over the years, I have come to recognize as my kind of thing. I am hard put to it to describe in words just what that amounts to; the pictures must speak for themselves.

For a painter to put words alongside his pictures like this, in an attempt to explain what he is up to, may be asking for trouble: stated intentions may only invite unfavourable comparisons between what is attempted and what is achieved. And what follows may perhaps demonstrate that I do not always practise what I preach. But then, how many of us do?

AN EYE FOR COUNTRY

There is a great deal more to landscape than meets the eye. Even for a painter, it is not just a scenic backdrop, and if my response to place is to find its way into the painting, I like to feel that – however briefly – I am occupying an environment.

I suppose I became addicted to places at an early age, probably during sedate country walks with my parents on summer evenings, dressed in our Sunday best. But there were less sedate occasions when I roamed the lanes and hedgerows and thistly pastures, poking about in ponds, paddling in brooks, identifying specimens on the gamekeeper's gibbet, and exploring derelict watermills. We must have covered miles on those childish expeditions, returning home tired and scruffy, clutching bedraggled wildflowers, a couple of bird's eggs, or a jar full of newts and waterweed. Had I thought about it at all, I would have regarded this familiar territory not so much as landscape or scenery, but as temporary habitat.

La Poulinière

225 × 290 mm (9 × 11½ in). This landscape shows how little is needed to make a picture.

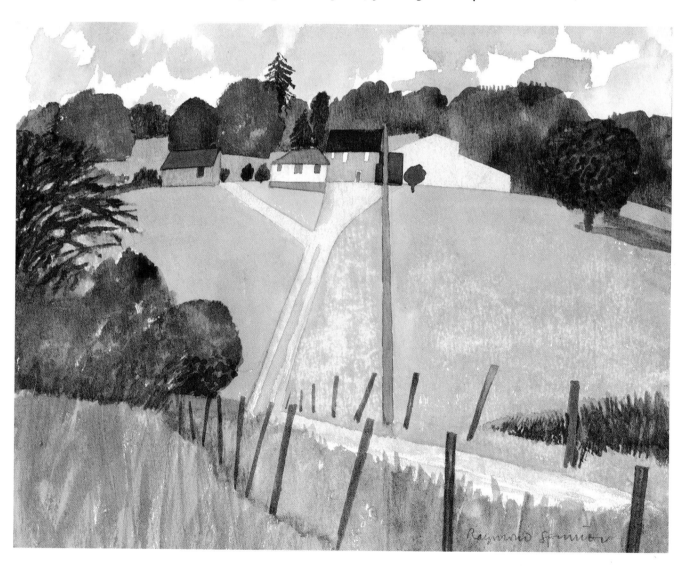

Later on, while riding to hounds on a bicycle, I developed an eye for country that had nothing to do with art. By then I had become aware of the power of the pen-and-ink drawing then common in every sort of publication. There was a man who did a weekly drawing of village scenes in our local paper, and I thought that it would be nice if I could do this too. So I studied the topographical drawings in magazines and newspapers and made tolerable copies of the better ones; although when I chose my own subjects the results were, to say the least, disappointing, lacking the sparkle of professional ink work. I could mimic the style and technique of proper artists but I had not learned the importance of composition and the need to select and reject from the confusions of reality, or how to balance pattern and tone values: in other words, I had not learned to see my subjects as drawings.

In those early days I had a lot to learn. Moreover, the countryside in which I was brought up was undistinguished, and I assumed that real artists all lived in prettier places. There was nothing spectacular or dramatic about our sluggish river valleys or the slack contours of the undulating pastures. I suppose the trouble was that it was all too familiar. Because it was part of me, I took it for granted and never really 'saw' it properly. So there was another lesson as yet unlearned: that you can make art out of the most unpromising subject matter once you have found out how to look at it.

There followed a decade or so when I became a surveyor and saw the landscape in map form, as terrain to be traversed and triangulated and divided into neat parcels, its features fixed with conventional signs, precisely drawn and sometimes coloured with thin,

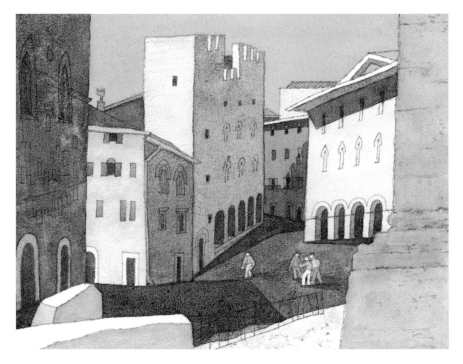

transparent watercolour. Landscape had become a diagram.

I mention these things because when, years later, I came to paint the landscape, I could not help seeing it as an all-embracing habitat in which one moved about, experiencing it from all angles rather than observing it from a static viewpoint behind an easel – an artificial stance only logical after the innovation of Renaissance vision. Before monocular perspective was introduced in fifteenth-century Florence, artists painted marvellous pictures which were often little more than diagrams of reality, using the multiple viewpoint that is our common experience to depict what they knew rather than what they saw.

Conventional perspective has its uses, but art is more than copying what we see. Moreover, nature rarely provides us with conveniently composed views. In nature, design is ecological while aesthetics is a human concept. A taste for scenery only developed after artists imposed their aesthetics on natural features.

Piazza

185 × 245 mm (7¼ × 9¾ in). An Italian townscape in which the sense of urban enclosure is captured without conventional light and shade, or perspective.

And so I like to analyse my subject, take it apart mentally, and put it together again in a form that works pictorially, working towards a composition that will ensure a coherent and self-contained image with an internal logic not always evident in that fragment of landscape I have selected to paint. Thus the process of painting begins long before putting brush to paper.

I shall say more about my working methods later. Meanwhile, if my approach to painting is to make sense I must say a little more about the landscape itself – a changing subject if ever there was one.

THE CHANGING LANDSCAPE

More often than not our appreciation of landscape comes to us indirectly through paintings and photographs. Medieval painting, described by Kenneth Clark as a 'landscape of symbols', alerted people to the pleasures of real landscape, while in the eighteenth century people of sensibility were much taken with the idealized views of Claude and Poussin and went searching for suitably romantic scenery to sketch, much as today we take holiday snaps. The manner in which watercolours were then made, by professionals and the new class of amateur, is thought of today as being traditional. In fact the English watercolour tradition is one in which styles and techniques varied in accordance with fashion and social change. That tradition is still evolving and today's styles are part of it. Yet many a present-day painting resembles a period piece reflecting bygone attitudes, despite the startling changes that have occurred in the landscape itself and in art too.

Ever since the dawn of history mankind has been altering the face of the land, exploiting the natural habitat for survival, for pleasure and, more recently, to support an increasingly sophisticated lifestyle so that the countryside I knew as a lad has now changed out of all recognition. Agricultural patterns have varied over the centuries while a vast array of artifacts have been accumulating, from early megalith to recent radar beacon, from Norman castle to nuclear power station, from the large-scale graffiti of the white horses that decorate the downland of southern England to the arabesques of motorways. Landscape can now be read as a diagram of social change and it is this human intervention which, for me at any rate, makes it such a fascinating subject to paint.

The more ancient intrusions have mellowed into the environment and have at one time or another been featured in landscape art. The more recent are usually edited out of paintings because they are thought to be inartistic. Yet we can imagine how Turner might have relished painting a cluster of concrete cooling towers with steam billowing into the evening sky.

Nowadays we are bombarded all the time with new kinds of imagery. Computer graphics, for example, would have startled our forefathers much as Renaissance perspective must have puzzled those brought up in the medieval tradition. Modern art too has shown us new ways of seeing and, since the turn of the century, has been modifying our expectations of what a picture can be like. Some of it might have been specially devised to cope with the look of the modern landscape.

Moreover, we actually experience landscape differently today – more often than not as territory to be traversed, usually at speed en route to somewhere different, although not necessarily better. The standard foreground is an unrolling ribbon of tarmac bordered by signs and symbols, while the residual landscape is seen with peripheral vision at the edges of the windscreen.

It is therefore perhaps understandable that we tend to view the diminishing countryside through a nostalgic haze, yearning for the pastoral simplicities of what seem like better times. Small wonder that so much popular art echoes that yearning.

But as serious painters, we cannot afford to live in the past. In days gone by, artists painted the landscape of their own time and in the style of the time. In the late twentieth century we should be doing the same. A modern landscape presents as many pictorial challenges as the old. It can still be seen as a landscape of symbols although the symbols may be different while today's technological artifacts are just as valid a subject for art as the low-tech objects of earlier times, like the windmill and the haywain.

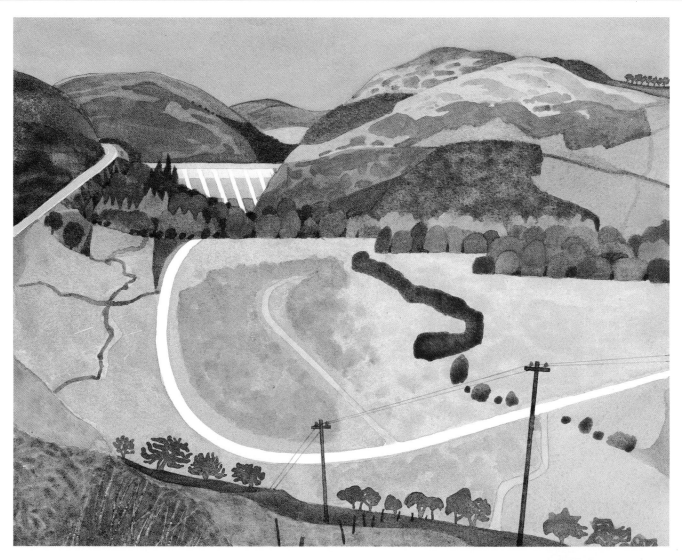

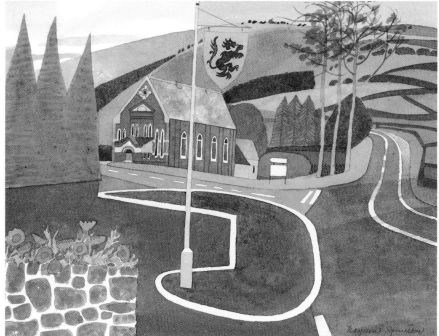

(Above) *Waterboard Country*

275 × 350 mm (10¾ × 13¾ in). An ancient terrain made more dramatic by the presence of man-made features.

(Right) *Welsh Chapel and Dragon*

230 × 310 mm (9 × 12¼ in). A landscape of symbols. The road markings and tree verticals provide a useful contrast with the curves of the hillside.

(Left) *Californian Highway*

70 × 245 mm (2½ × 9½ in). A twentieth-century landscape of movement.

Confronting the Subject

People who take up landscape painting on the promise of nice relaxing hours in the open air on fine days soon encounter those other delights of working outdoors: changing light, paper dazzle, scattered showers that can play havoc with watercolour, the breeze that can rock an easel, blow away paper, and deposit dust on a wet wash, to say nothing of such aspects of nature in the raw as marauding spectators, bothersome insects and other species of wildlife.

Munching cattle are much attracted to painters, and will slowly but inexorably advance to investigate. Free-range horses are quicker off the mark. I have had them trying to eat my paint while blocking the view with a gleam in their eyes of Thelwellian malice. I

have also been enveloped by a herd of Greek donkeys clattering down a stepped incline where I was working, flowing past me like a mountain torrent round a protruding boulder. They were followed by a pack of children released from the neighbourhood school. Given the countless other irritations that can break the concentration, it is no wonder that Degas said that art was not sport and remained steadfastly indoors.

For these and other reasons I rarely paint in front of the subject. It is difficult enough to compose a picture; and when nature is staring you in the face, daring you to get it wrong, it is only too easy to be seduced by reality and paint in a lot of irrelevant detail just because it is there. The likelihood of producing a frameable picture is slim.

On the other hand, when the mood is right and conditions are perfect there is nothing quite like it: that direct confrontation, the sense of immediacy, and the spontaneity that can never quite be recaptured in the studio. Once experienced, these

tingles of excitement can be induced on subsequent occasions, much as professional tennis players hype themselves up before a match.

To paint a tolerable picture we have first to observe the subject and translate it into two dimensions on the paper while deciding what to put in and what to leave out. We must then summon up other technical skills in order to balance line, tone, colour, rhythm, texture and pattern, and shape and combine them into a convincing unity: a juggling act of no mean order. All aspiring landscape painters must, of course, get to know their subject by working out there in front of it. But for those eager to splash out into full and glorious colour straight away I can only advise restraint. Take it slowly, solving one problem at a time.

For years I did little more than draw, trying to get down fairly accurately what I was looking at because that was what I thought drawing was about. Then I learnt to select only what was pictorially relevant. Eventually, with more experience, I found myself giving way to gesturally expressive exaggerations and the drawings became more lively.

The next logical stage was to add some monochrome tone. For the budding watercolourist this is best done with a brush – a bigger one than you think you need. I found it convenient to use ordinary black writing ink diluted with water, though watercolour black would do just as well. This line and wash drawing was one of several made during a day of wandering among the vines and olive groves of Elba. I had paints with me but I do not think colour would have added much, partly, I suspect, because I saw the subject in monochrome terms.

Near Capoliveri, Elba

250 × 330 mm (10 × 13 in)

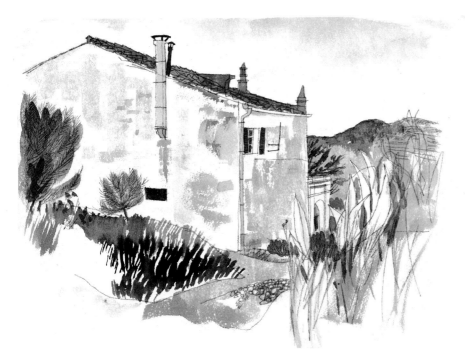

COLOUR SENSE

Colour, when you come to it, should be approached cautiously, starting with a limited range – not because there is any moral virtue in such restraint but because it helps to get to know a few pigments at a time, their chromatic and physical characteristics and what happens when you mix them. Thereafter, you can extend the range gradually, adding a new colour only when you feel an urgent need for it.

Colours do not have to match those you perceive in the landscape. Indeed they can be varied for all sorts of reasons: structural, symbolic, decorative, or emotional. It is possible to paint a convincing picture using only two colours, a warm and a cool one. Here and there they can be mixed or overlapped to produce a third of more middling colour temperature. Such a restricted palette was good enough for Girtin, Turner, Cozens, Cotman and many other painters during that great century of the English watercolour tradition between 1750 and 1850.

The picture on this page is another pencil drawing overlain with a limited colour range. It is not far from being in monochrome, but I think it displays some of the excitement that comes from working outdoors under ideal conditions, in this case a secluded olive grove on a quiet Greek island afternoon.

Colour theory, in my view, is unimportant. Before it was devised, artists managed very well without it and many have done so since. Of course it is useful to know about warm and cool colours, about complementaries and simultaneous contrasts. Far more important for the painter, however, is colour practice: a knowledge of pigments and how they behave. It is useful to

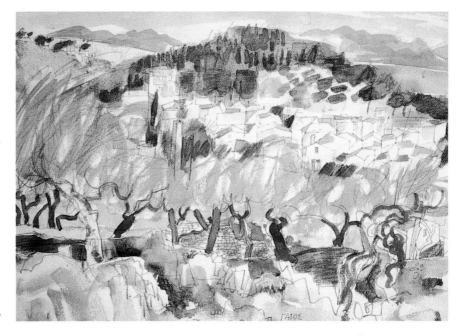

Gaios, Paxos

250 × 350 mm (10 × 14 in)

know before you ruin a masterpiece that, for example, the blues are all different. French ultramarine will granulate (unless you specially want it to); Prussian blue will fade; cobalt can be lifted out again leaving white paper; Winsor blue is very powerful and a dye that will not come out; while cerulean is almost impossible to handle in a flat wash (at least by me!). All the pigments have their own characteristics. Some are more transparent than others, while the mixtures do not always work according to theory. Certain reds and blues, for example, do not produce purple; certain reds and yellows are incapable of the singing orange you had hoped for; while green can be made out of yellow and black. There are also fugitive colours which are not to be trusted. Some of this information can be gleaned from a close reading of the maker's catalogue; but most of it is best acquired by experiment.

If I refrain from describing my own palette or favourite mixtures, this is not because I want to keep them secret but because it is better to find out through practice what best suits your style and vision. In fact if

you have a good eye for colour you may be able to work out the mixtures from the illustrations.

You may be attracted to paint a landscape just because of its colour combinations. In that case, it pays to analyse exactly what makes them attractive and whether by accentuating one colour, playing down another, or changing their proportions the impact can be enhanced. The opposite can so easily happen.

John Ruskin went so far as to advise those to whom colour did not come naturally to steer well clear of it. You may perhaps prefer my more optimistic view that a colour sense can develop almost without your realizing it if you approach it progressively. It is no good dipping at random among the eighty-seven seductive pigments available from one well-known manufacturer (of which six are fugitive and nine only moderately durable, including the popular sap and Hooker's green).

DRAWING TO A CONCLUSION

John Ruskin also said long ago that
anyone can learn to draw what is
seen; the difficult bit was learning to
see. Some would say that learning to
draw *is* learning to see, for only by
drawing do you find out what things
are really like. Only then
can you take liberties with
appearances in the interests of
artistic expression.

Apart from the sheer pleasure of
drawing for its own sake I use it as
preparation for painting, and in two
ways. The first is as a means of
getting to grips with the subject. I
have no specific routine for this.
Much depends on the circumstances,
the time available, the mood, the
weather, the nature of the subject,
and so on. I may start with a fairly
accurate representation of what is
there. Then I may make analytical
studies in order to explore form and
structure and those important
relationships between the various
elements, observing shapes and the
spaces between them. I may also
sketch the same subject from slightly
different viewpoints or even move
about a bit as I draw to see if things
fit together better. This is the time to
note what comes next to what and
maybe make adjustments. Lower the
viewpoint a couple of inches and
half a mile of countryside may
disappear. I have even been known
to face the other way in search of a
better foreground or background.

There are many ways of exploring
a particular landscape through
drawing, any one of which could
form the subject of a separate
picture. For example, you might
start with a study of the basic
geological form, then go on to
examine light and shade and passing
cloud shadows, the interlocking
rhythms of hill forms, the geometry
of field shapes, or the surface pattern

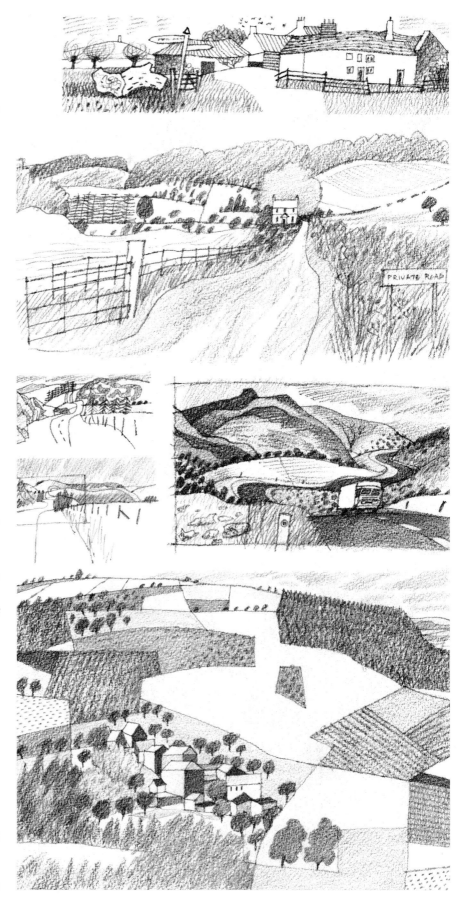

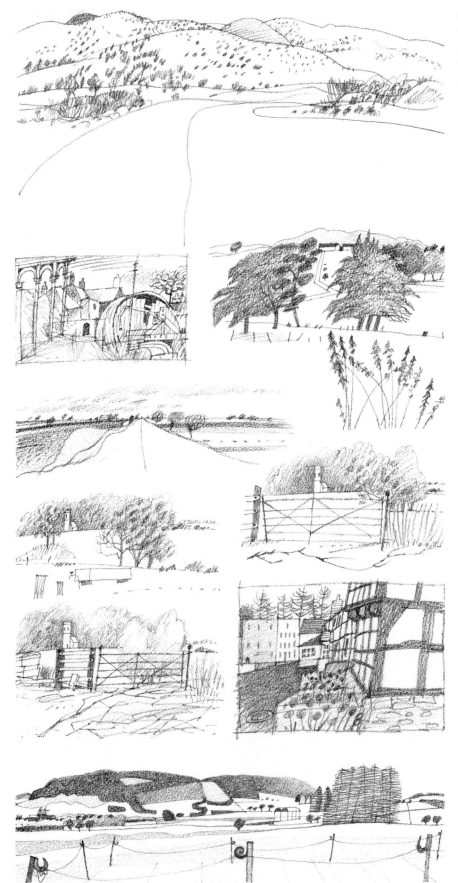

of cultivation and woodland. In this way even the most unpromising subjects reveal hidden subtleties. What I mostly look for are the formal, abstract qualities that can be hiding among the confusions of nature, qualities that are the basis of all art, however representational.

Some of this work may well overlap with the next stage, which is to use drawing as a design process: simplifying, selecting, rearranging, and generally testing the compositional options to find out which comes nearest to what I want to express. This involves making a number of purposeful doodles, keeping them small to avoid getting into detail, and laying myself open to whatever they suggest until one of them clicks into place with a nice feeling of inevitability – and then I wonder why it took so long to achieve the obvious!

The drawings on these two pages form an arbitrary assortment of preparatory sketchbook notes, studies, and compositional try-outs. With experience you may find it possible to leave out some of these preliminaries. A subject immediately perceived in pictorial form may need only a single on-the-spot drawing. But there is no knowing when this may happen.

Finally I enlarge the selected design to its finished size, saving time by using a photocopier. The resultant print is crude with thickened lines so I lay tracing paper on it and redraw, using the field sketches as reference but taking care not to lose the main impact of the design. This new drawing may go through several versions until all is well and ready to be transferred to a sheet of watercolour paper.

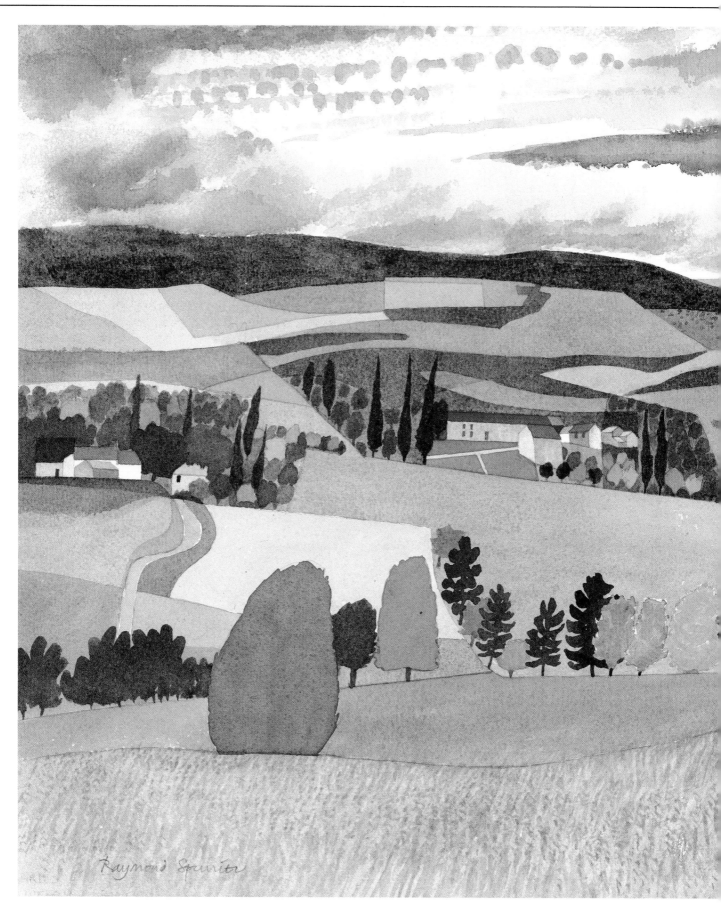

Raymond Spurrier

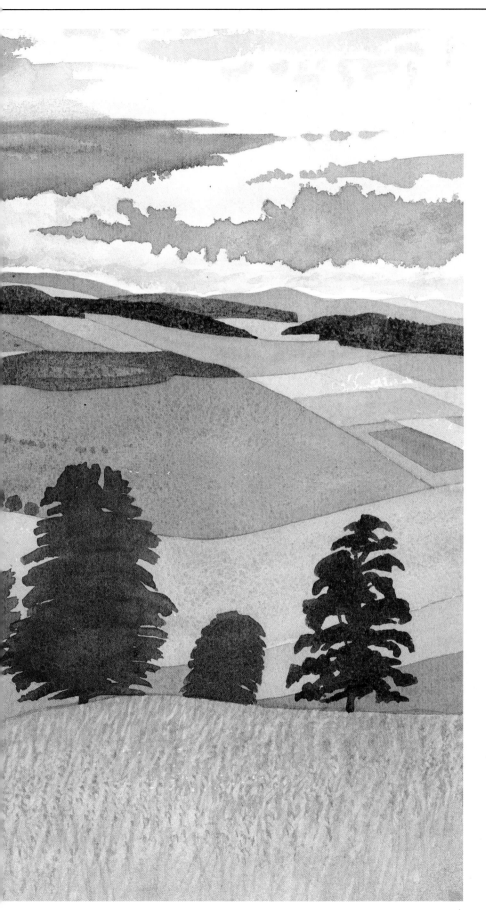

APPLYING PAINT

With the ground thus prepared, you might suppose that the rest is easy, merely 'colouring in' between the lines. Not so. The lines are only a guide and a means of reducing the odds against me. I now have to start to think in terms of painted washes and how they will relate to each other as adjacent patches or overlapping colours.

The first few moments are the worst because the white paper can be inhibiting and misleading. A first wash will invariably be too pale when the rest of the paper is covered. So I must be prepared to make adjustments while proceeding and I begin where the result may be not too critical.

I also like to establish a few darks early. I know this is not the way 'classical' watercolour is done, but then I am not that sort of painter. Thereafter, every brushstroke has to be judged against its neighbours. I am not concerned with matching natural colour but I am concerned with how one colour will balance or offset another, and work in relation to the picture as a whole to create an overall harmony, not forgetting the occasional discord and the way an arbitrary hue may set up unexpected resonances with what is already there.

The painting process is thus intuitive. It has to be because water-colour is a tricky medium with a life of its own. You never quite know what it will do next and you have to keep alert to the possibilities: the chance of a happy accident or, more likely, the unhappy disaster. But I

Lozère Uplands

367 × 532 mm (14½ × 21 in)

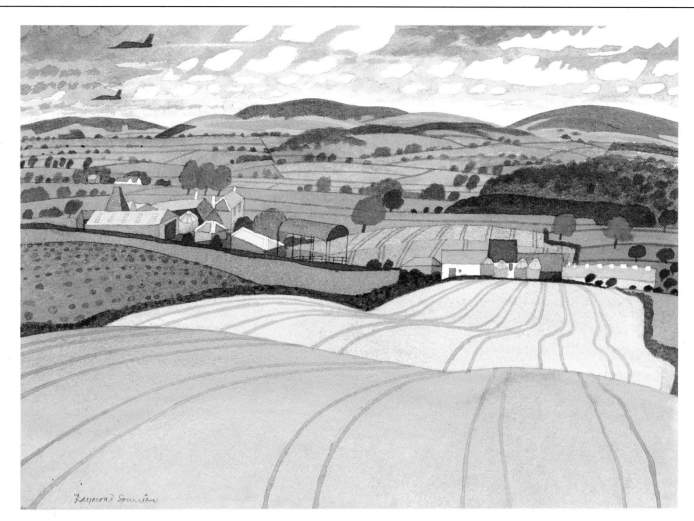

Country Prospect

236 × 330 mm (9¼ × 13 in)

think this knife-edge uncertainty about how it may turn out is what keeps the work lively and possibly more expressive. There is only one way to learn to paint and that is to keep at it!

LANDSCAPES IN TIME

On the face of it this painting represents one of those delightful tracts of rural England that seem timeless. Indeed, the distant hill slopes with their woodlands and rough grazing have probably remained unchanged for centuries. The valley pastures, on the other hand, were doubtless created during the eighteenth or nineteenth centuries when parliamentary Enclosures divided up feudal strip-

farming into ten-acre fields with cattle-proof hedges, much to the annoyance of the peasantry. The foreground fields are clearly the result of present-day agricultural practice that removes hedges to make conveniently large areas for machine harvesting, much to the annoyance of environmentalists.

The farm buildings are a mixture of old and new, ancient brick and tile amongst prefabricated sheds clad in metal sheeting. Yet despite the evidence of change, the various elements combine to create a peaceful country prospect – an idyllic slice of the 'coloured counties' that A E Housman wrote about so emotively in A *Shropshire Lad*. But this is no 'idle hill of summer'. In the next field a complex piece of machinery clanks and chews its

steady progress through the crop and the farm workers' cars are parked untidily in the lane behind me. The narrow twisting lanes hidden in the middle distance are alive with speeding Land Rovers and clumsy tractors.

So the peace is largely an illusion; but then, so too is art. And if there is any doubt about this being a late-twentieth-century landscape two jet fighters scream across the sky as I stand drawing and, in a strange way, are perhaps helping to preserve at least an illusion of peace.

Foregrounds can often be a problem in landscape painting and in this view I needed something to

complement the interest in the middle distance. The sheep sign, already sketched for my own amusement, seemed ready-made for the job. Furthermore, its insistent white shape echoes the white house on the extreme left while the red triangle is also repeated on the left by a red roof, thus dragging the eye across the picture, while triangles turn up several times in gables, and so on. The careful observer will be able to spot other design elements that hold the composition together, such as the way the shape of the sign has unconsciously dictated the picture format.

Of course it is easy to analyse a picture after the event and to apply design logic to features that were included intuitively. It is nevertheless good practice because the analytical approach can help you to tease out the essentials when sketching from an often unruly nature.

Sheep rustlers in the peaceful fastnesses of Wales: whatever next! Yet this witty warning notice transforms what might have been no more than a pretty picture into something of a social comment on the state of today's countryside.

Farm Watch

305 × 327 mm (12 × 13 in)

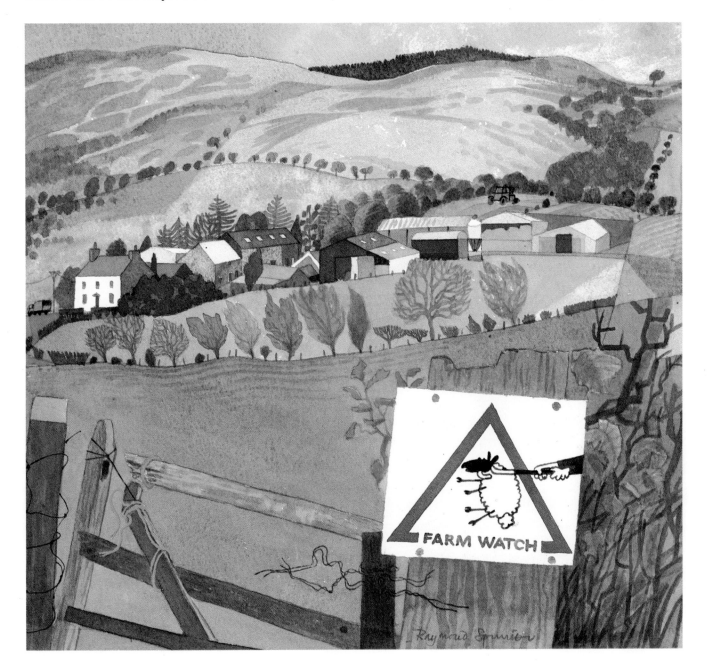

SERIAL VISION

When friends reported they had encountered one of my subjects while out driving I went to have a look. I parked the car at a convenient spot, then walked back up the hill to find the viewpoint, only to discover that it did not exist. I had become the victim of serial vision, glimpsing from the driving seat a sequence of separate vignettes all fused together into one impression by the speed of movement. This is a familiar experience so I knew what I had to do: make a series of sketches from separate viewpoints and later arrange them into a convincing unity that reflected the initial impression. The painting on this page is the result.

In making it I much enjoyed the contrasts between the hard-edged raw colours of the buildings and signs and the softer country tints, between the geometry of walls and fencing and the natural shapes of foliage – a mixture of ancient and modern that is so much a feature of today's landscape.

The painting opposite represents a very similar experience. Driving down the Pacific coast of Australia we topped a rise and suddenly the road plunged steeply in front of us, dropping first to the valley and then streaking up the opposite hill. I recognized the scene as a potential painting, with its contrasts of woods and farmland and sea, all sliced in two by the smooth blacktop highway and its abstract pattern of white traffic markings. We had a long way to drive and there was no time for sketching so I reached for the camera and took a couple of reference shots that I knew would never be more than a reminder. My feelings at the time remained with me and, months later, I made some compositional doodles in an attempt to encapsulate them, eventually arriving at an image only made possible through serial vision.

(This page, below)
The Red Garage

270 × 400 mm (10½ × 15¾ in)

(Facing page, above)
These sketches of the same landscape were combined to produce *The Red Garage*

(Facing page, below)
Coastal Highway

306 × 425 mm (12¼ × 16¾ in)

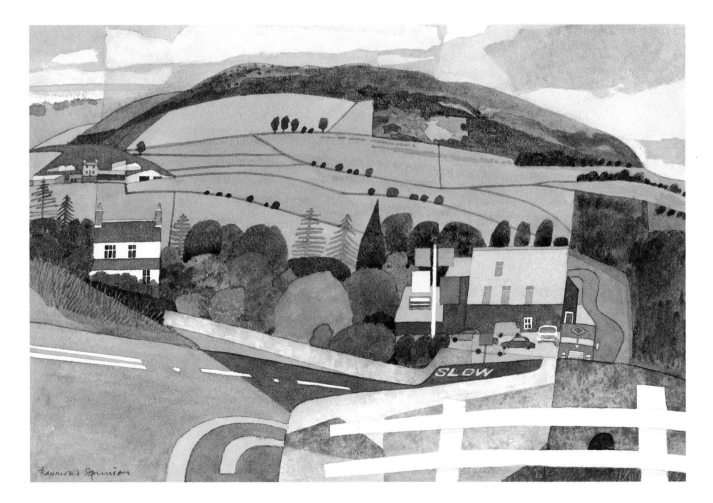

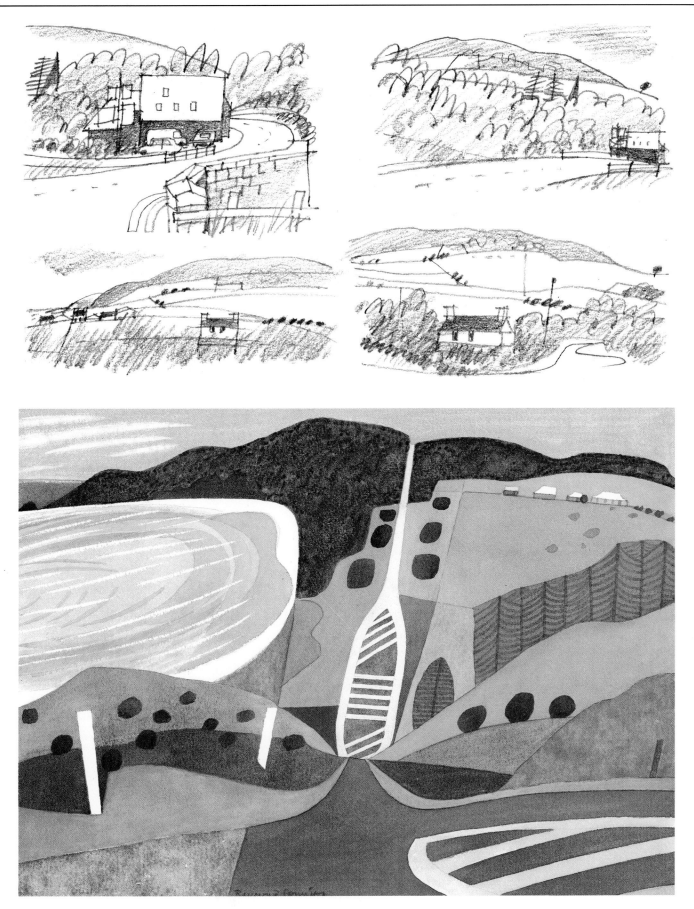

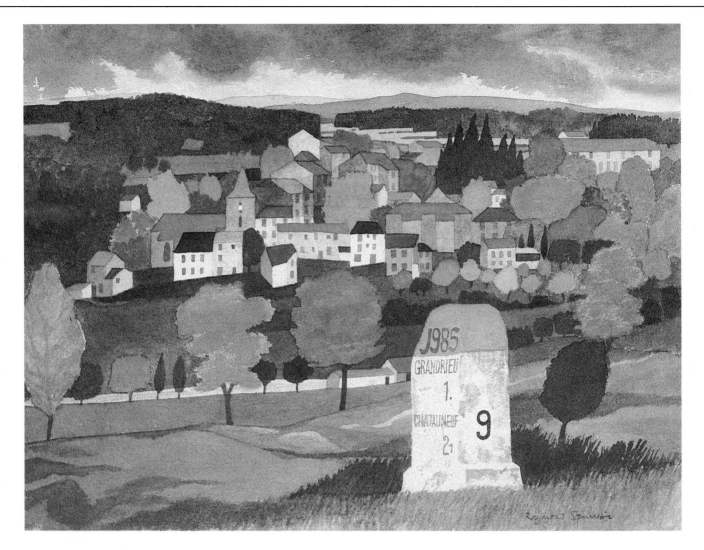

BUILDINGS
IN THE LANDSCAPE

Singly or in groups, buildings provide added interest in a landscape, even a focal point if carefully positioned in the composition. They can also be treated as the main feature.

Past generations seem to have developed a happy knack of putting buildings in just the right place, so that village and farmstead often nestle cosily among the contours as if they had grown up naturally from seed, thus forming subjects much sought after by artists with romantic tendencies.

The size, shape and siting of farm buildings is dictated by function and convenience yet is full of visual interest. An array of old barns, sheds, stables, oasts and silos, together with odd bits of equipment, brightly painted or left quietly to rust among the nettles, can almost be treated as a giant still-life if those important relationships between shape and form, solid and void, are carefully observed and manipulated. Even the modern farm layout with its gaunt grey sheds and concrete aprons can provide subject matter for those with a contemporary eye.

Ours is a landscape in transition. We have lost the instinct for apt siting. More often than not, modern development seems to have been plonked down without much thought so that today's landscape

Grandrieu

254 × 355 mm (10 × 14 in)

can look like a badly assembled collage. This too is a challenge for the contemporary painter. As artists we can make the world the way we want it: we are in charge of our own pictures and even the commonplace can be transformed into something exciting, perhaps more so than the overtly picturesque which has become stale with repetition over many generations.

The painting above shows the clustered buildings of a small French town in its landscape setting.

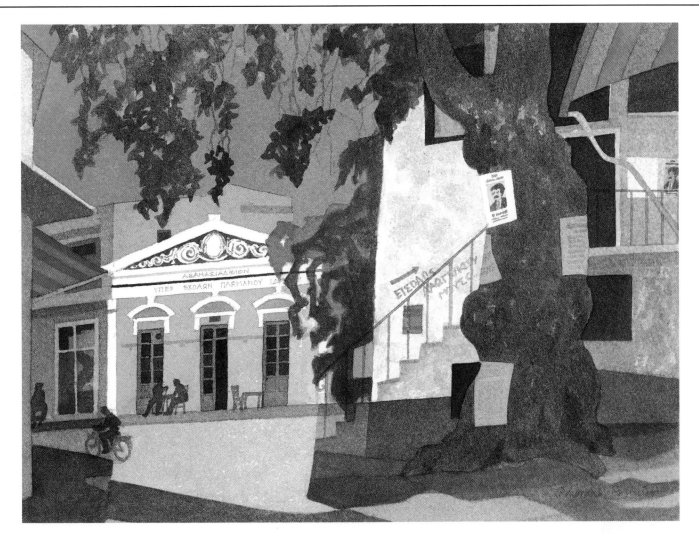

Ploumaris, Lesbos

253 × 340 mm (10 × 13½ in)

A common theme in topographical art, townscape seen from a distance is familiar from medieval woodcuts and the backgrounds of early Italian frescoes – well worth studying if only for the delightful compositions that were possible without the use of conventional perspective. On this page is a close-up of townscape seen from within where vernacular building, imposing architecture and natural forms mingle in a small Greek island port.

TOWNSCAPE

Townscape is the urban equivalent of landscape, although because of the density of building and incident the pictorial scope is more varied and the emotional impact more intense. Even in the sleepiest places on early-closing day there is plenty of visual excitement from which pictures can be made.

In the first place towns offer a choice of architecture from different periods in contrasting styles and materials. More important than the buildings themselves, however, are the spaces they define, infinitely variable in size, shape, and feeling: broad street, narrow alley, quiet enclave, or bustling market place.

Serial vision really comes into its own in towns. New prospects unfold and change every few paces so that the emotional pressures fluctuate according to the way buildings combine and recombine to create a feeling of movement or repose, sensations of enclosure and release, concealment and revelation, anticipation and climax, and sometimes unexpected urban drama. On these things the wandering artist can capitalize.

Moreover, the buildings and the spaces they surround are further articulated with all sorts of oddments: pillar boxes, lamps, bollards, railings, awnings, fountains, steps, archways, the texture of paving patterns, road signs

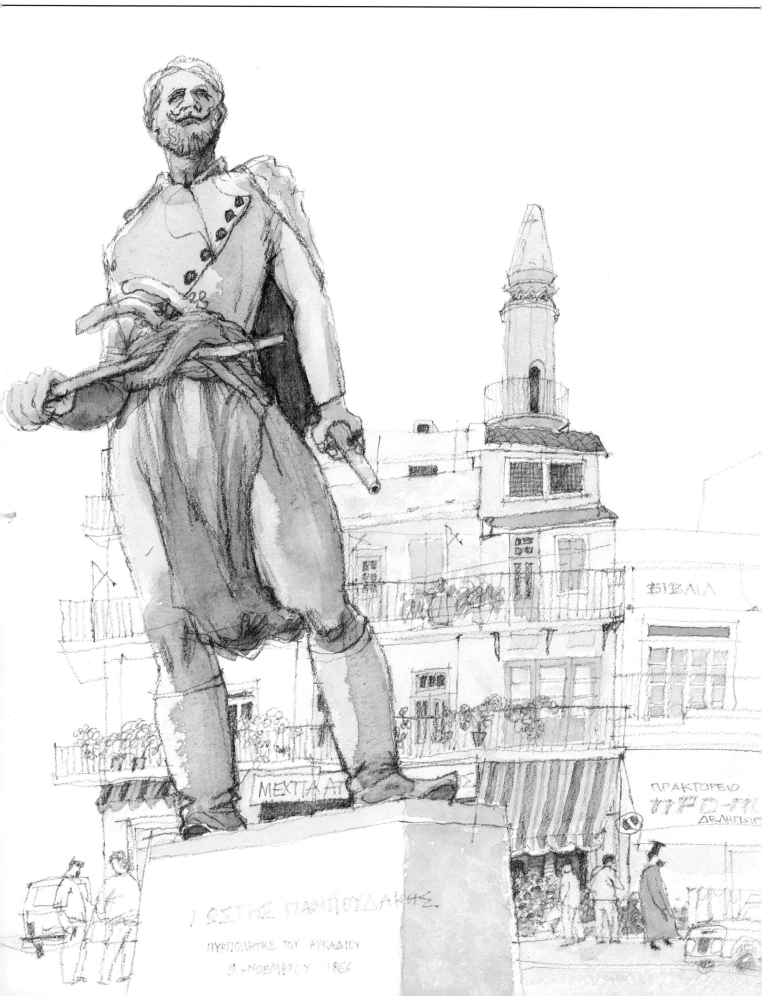

(Left) *Greek Hero*

400 × 320 mm (15½ × 12½ in)

(Right, top) Sketch of Arezzo

(Centre and below) The same building acts as a focal point in a townscape seen from two viewpoints

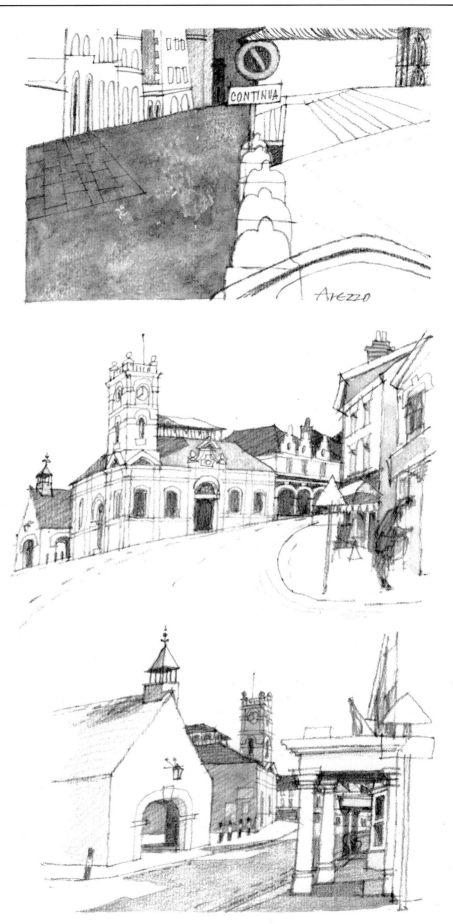

and traffic markings. Even the severely functional can become decorative. Those double yellow lines, so annoying when you are trying to park, can make useful foreground incident. Note, for example, in the sketch of Arezzo how the large empty space in front of the cathedral is brought alive by steps, bollards and road sign – things that are visually more important than the surrounding architecture, at least in this view.

The important thing is to see objects, not for what they are but as abstract elements that can be manipulated for pictorial effect. We are back to that matter of relationships: plain against fancy, useful against ornamental, street graphics against architecture, half-timbering against Victorian gothic or twentieth-century glossy. As you move around, the townscape becomes a shifting collage of impressions with contrasts of shape and scale and content, each of which, like complementary colours, intensifies its opposite. Seen through a gap in the buildings a tiny slice of countryside becomes twice as exciting – like a ship at the end of a street.

The examples on these pages are little more than a set of thumbnail diagrams, a mere hint of the wide range of possibilities open to anyone exploring the urban labyrinth with a sketchbook. They are culled from

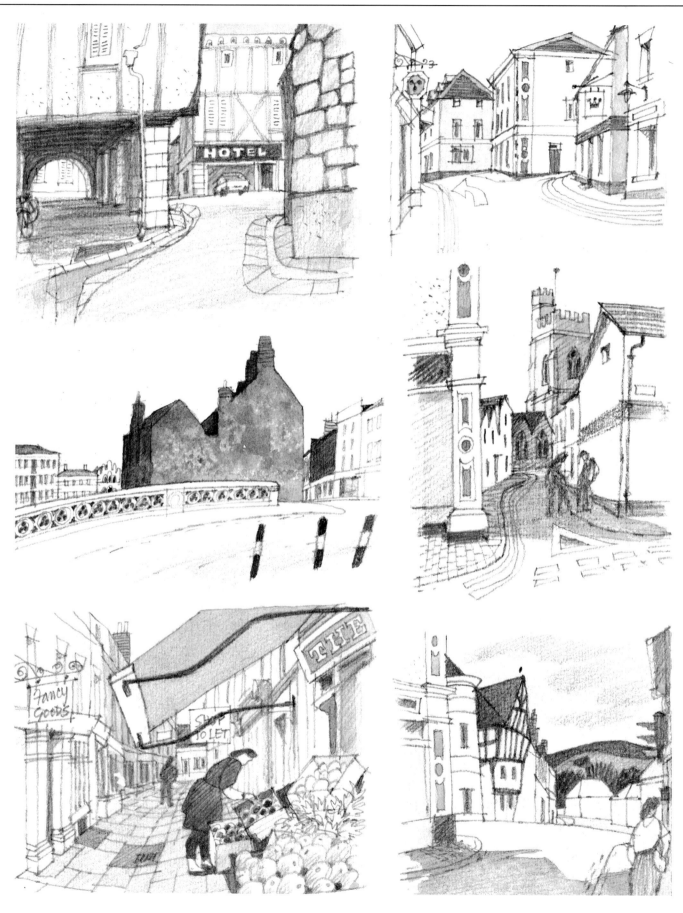

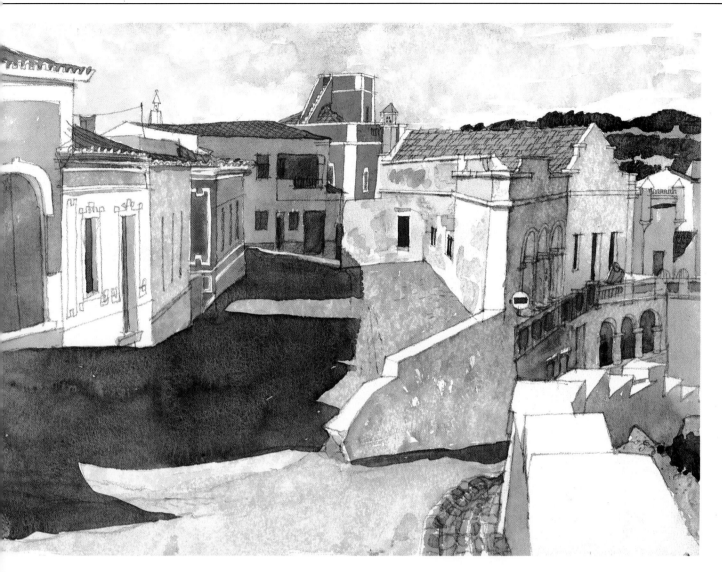

(Above) *Carvoiero, Portuguese Townscape*

254 × 344 mm (10 × 14 in)

(Facing page, left column)
Top *A tight-knit French townscape.*
Centre: *A different kind of urban space.* Below: *An intimate pedestrian alley enlivened by signs and foreground incident.*

(Facing page, right column)
The same building reappears in different views.
Top and centre: *The vistas are enclosed by buildings.* Below: *The townscape suddenly opens up.*

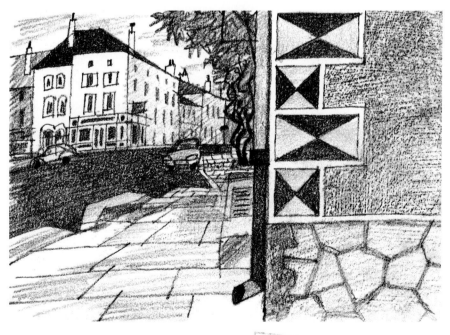

places in England and Wales and abroad; but where they are is of little consequence because towns and cities throughout the world present a vast vocabulary of urban form in all its variety. Once the probing eye has become attuned to the subtleties of townscape, many an ordinary street scene can be turned into a potent image far more personal and evocative of place than the standard picture-postcard view.

LANDSCAPE TARGET

This picture summarizes my attitudes to changing landscapes and to the search for those relationships and abstract patterns which can structure a painting. Salisbury Plain is much affected by human occupation, from Stone Age megaliths to modern military clutter. Here this is evident in the scribble of tank tracks on the hillsides, danger notices and the yellow-topped markers to show where tanks may cross the public highway.

vehicles have churned up the chalky earth into a semblance of the camouflage patterns on combat clothing. Ideas like this only emerge during the slow process of designing and adjusting the composition as I paint. Abstract art is not the easy option that many think. Indeed, this painting is by no means as abstract as it might have been. If it is here and there ambiguous about what exactly is what, then life is full of ambiguities, while today's landscape is a prime target for change and human folly. As I have already said, there is more to landscape than meets the eye – and more to painting it than descriptive topography.

PERSONAL CHOICE

There are many ways of painting a picture and mine is only one of them. There is no single right way. If anything, the choice is too wide. The chances are that whatever we choose to do will not only have been done before during the centuries of art history, but will have been done better. Yet we are perhaps lucky to be the heirs to so many stylistic options, even within the limits of the watercolour medium. From among them it should be possible for any artist to choose something that best accords with his or her own temperament and way of seeing things.

Painting and drawing is a process of discovery, an exploration of the visible world. If we persevere with an open mind, trying to make something interesting happen on the paper, that special painter's eye will surely develop and, in time, we shall find our own artistic voice. Then we shall be able to say something personal about what we choose to paint.

The title may remind old soldiers of those topographical lithographs used to train recruits to locate a target quickly: 'left of arc, middle distance, reference white house, two o'clock bushy-topped tree, three degrees right black barn, enemy patrol . . .' In a similar way a good painting will direct the viewer's eye from one feature to another in a tour

Landscape Target

220 × 402 mm (8¾ × 16 in)

of the picture space, using the rhymes and rhythms of the subject.

Emblematic shapes that are metaphors for reality can also sometimes suggest more than one level of meaning. For example, on the right of this picture tracked

Biographies

Ray Evans has worked as a freelance illustrator, cartoonist and painter since leaving art college in 1950. He has also lectured on watercolour in North America. His cartoons have been printed in many British newspapers and magazines including *Punch* and he has worked as a resident cartoonist for a daily news programme on Southern Television. Of the several books he has written, two are specifically devoted to drawing and painting buildings. A member of the Royal Institute of Painters in Water Colours, he is also a Fellow of the Society of Architectural Illustrators and has made a special study of townscapes. A proposed television programme will illustrate panoramas drawn on active service in Italy and Africa. He lives in Salisbury, Wiltshire.

Moira Huntly was born in Motherwell, Scotland, in 1932 and studied at Harrow School of Art and at Hornsey College of Art in London. Vice President of the Pastel Society, she is also a member of the Royal Institute of Painters in Water Colours and of the Royal Society of Marine Artists, and has written many books on drawing and painting in a variety of media. Her work has been widely exhibited in the United Kingdom, Europe and North America and has won several awards, including the Laing Painting Competition in 1986 and the Manya Igel Fine Arts Award in both 1992 and 1993. She lives in Gloucestershire.

Neil Meacher grew up in coastal Kent and studied at Canterbury College of Art and the Royal College of Art, London, between 1951–60. Over the following 25 years he taught in art colleges, including 15 years as Director of Foundation Studies at Ealing Polytechnic. In 1981 he was elected a member of the Royal Institute of Painters in Water Colours. In 1986 early retirement enabled him to concentrate on a growing freelance practice as artist, teacher and writer, and as art trade features editor for *Leisure Painter* magazine. He now teaches at residential painting holiday centres and gives lectures and workshops. His artwork derives its inspiration from the sea, translated as a heightened idyll where sunlight floods the composition.

Raymond Spurrier is both artist and writer. At one time he often appeared in *The Times Literary Supplement* and the *Architectural Review*, and for seven years wrote a regular column for another, now defunct, architectural monthly. He has also written for such publications as the *Illustrated London News*, *Heritage*, *Period Home* and *Watercolours and Drawings*, and during the past decade has become a frequent contributor to *The Artist*. He has contributed to several art instructional books and is the author of *Sketching with Raymond Spurrier* (Collins, 1989). He works mainly in watercolour but also enjoys printmaking. He is Honorary Secretary of the Royal Institute of Painters in Water Colours, a member of the Royal West of England Academy and a member of the Board of Governors of the Federation of British Artists. He has been twice a finalist in the Hunting Group Art Awards and in 1984 won the Winsor and Newton 150th Anniversary Award for the best group of paintings in the annual RI exhibition.

Norman Thelwell was born on the Wirral peninsula in 1923. After serving in the army during World War II, he went to Liverpool College of Art and taught at Wolverhampton College of Art for six years before turning freelance. During the next twenty-five years he worked primarily as a cartoonist for several British newspapers and magazines. In particular he had a long association with *Punch*, for which he produced sixty covers and over 1,600 drawings. He has published more than thirty books on a variety of subjects and these have been translated into many languages. Since childhood he has continued to paint landscapes, mainly in watercolour. Their specifically English quality is clearly visible in his cartoons and his illustrative work.

Roy Perry

Roy Perry was a painter in the true tradition of English watercolour painting and yet he painted mostly with acrylic paints, a relatively modern medium. To see him during one of our annual workshops, when he would hold us enthralled by completing a painting in fifty minutes, was to see a true professional at work. He would paint a landscape measuring about 50 × 75 cm (20 × 30 in) on a piece of card, using the merest pencil sketch for reference. He painted with a decorator's brush and a couple of smaller, rather scruffy artist's brushes, a painting knife, a piece of cloth and his fingers, dipping all of these very occasionally into a large can of water. His favourite comment, for which we all waited, was, 'I'll just add a smidgen of red here.' He would talk in this way for much of the time, engaging in a certain amount of banter, until someone would be bound to interject with that old chestnut of a comment familiar to all artists who demonstrate: 'And now with a few deft strokes he'll pull it all together.' And that is exactly what Roy would then proceed to do.

His paintings could create vast landscapes, brooding skies, luminous stretches of water and fields. He could introduce a long line of cows against a dark background, using a painting knife or his fingers (with or without a cloth), in a matter of minutes. I think that one of his greatest skills was to create a panoramic landscape in a sketch only a few inches square. He would set out to paint after breakfast and return in the evening with eight or ten small thumbnail watercolour sketches of exquisite quality. He had no pretensions other than to be himself, creating only what he was very good at, and not attempting to work in other styles.

Roy was no mean raconteur and had a fund of humorous stories, not just about painting. He was self-taught and had at one time been an accountant. He and his wife Sallie were great travellers, having been to China and to the West Indies, which they visited on several occasions. Roy shared the West Indians' love of cricket, and was particularly well known for his studies of cricket grounds; many of these paintings were made into limited-edition prints, which helped to raise money for The Lord's Taverners, a charity of which he was a keen and active member. He also opened the batting for his local village cricket team.

We hope that this book will be something of a memorial to him, as he was to have been one of its authors. He was far too young to leave us.

Ray Evans RI, FSAI
Salisbury, May 1994